POSTCARD HISTORY SERIES

Indiana County

Indiana County was formed from parts of Lycoming and Westmoreland Counties by the act of March 30, 1803. This act provided that the "courts of justice shall be fixed by the Legislature, at any place at a distance not greater than four miles from the center of the said county." When the trustees of Indiana County received a deed for 250 acres from George Clymer on September 7, 1805, the county seat, Indiana, was born. After the initial sale of lots in December, the first court session was held in 1806. A log jailhouse was erected, and the first courthouse was erected in 1809. These buildings were financed by sales of town lots provided by Clymer's gift. During its formative period, Indiana County encompassed seven townships: Armstrong, Blacklick, Center, Conemaugh, Mahoning, Washington, and Wheatfield. From these humble beginnings, the county has grown to 23 townships with a population of approximately 89,600.

POSTCARD HISTORY SERIES

Indiana County

John F. Busovicki

John F. Busovicki

ARCADIA

Copyright © 2003 by John F. Busovicki.
ISBN 0-7385-1181-1

First printed in 2003.
Reprinted in 2003.

Published by Arcadia Publishing,
an imprint of Tempus Publishing Inc.
2A Cumberland Street
Charleston, SC 29401

Printed in Great Britain.

Library of Congress Catalog Card Number: 2003100240

For all general information, contact Arcadia Publishing:
Telephone 843-853-2070
Fax 843-853-0044
E-mail sales@arcadiapublishing.com

For customer service and orders:
Toll-free 1-888-313-2665

Visit us on the Internet at www.arcadiapublishing.com.

The Clearfield Bituminous Coal Corporation's forestry department was organized in 1920. The company owned 18,000 acres of timber, which it used as a resource for structural and repair work of its mines and workers' houses. It built a sawmill and a planing mill in Clymer to produce the lumber it needed. The forestry department also established a nursery at Clymer to provide seedlings for reforestation. Pictured here in 1936, this woods crew cut timber in the winter and worked in the nursery during the summer.

Contents

Acknowledgments 6

Introduction 7

1. The Indiana Area 11

2. The Blairsville Area 41

3. The Homer City Area 61

4. The Clymer Area 75

5. The Marion Center Area 95

6. The Glen Campbell Area 107

7. The Heilwood Area 121

ACKNOWLEDGMENTS

Putting together this pictorial history of Indiana County has been a joy and something I have wanted to do for a long time. I have been collecting postcards, pictures, and memorabilia of Indiana County for 50 years, but it was not until I retired from the mathematics department at Indiana University of Pennsylvania that I had the time to attempt this project. When my former high-school teacher and mentor, Clarence D. Stephenson, agreed to assist me, I decided to begin. I cannot thank Clarence enough for his encouragement; he wrote the introduction to this book and some of the captions as well. I could not have written this text without relying on Clarence's five-volume *History of Indiana County*, of which I am a proud owner. I thank Coleen Chambers and Barb Waltemire of the Historical and Genealogical Society of Indiana County for their help in providing documentation when it was needed. Thanks are due to my niece and nephew, Gina and Jim Bertuzzi, for typing the text and to Judy Skubis for proofreading these pages. A big thank-you is extended to Connie Custer for typing captions and preparing this text for printing. I also am grateful to all of the generous people over the years who have encouraged me and donated pictures or postcards to my collection. Finally, I would like to dedicate this book to my parents, Blanche and John Busovicki; to my wife, Rose Ann; to my children, John, Joseph, David, and Lisa; and to my grandchildren Nicole, Diane, Lyndzey, and Zackary.

After the Clearfield Bituminous Coal Corporation began developing the towns of Rossiter (in 1900) and Clymer and Barr Slope (in 1905), the company turned its attention to developing the town of Commodore in Green Township. The mines opened in late 1919, and by 1921 the town had 100 company houses, a bank, a high-school building, a public garage, and this company store, the Clearfield Supply Company.

INTRODUCTION

Archaeological excavations indicate the presence of Native Americans in this area as early as 14,225 B.C. A Native American village near Blairsville was excavated in 1952 and has been dated between A.D. 1550 and 1600. The Delaware Indians were here during the 1720s, and the Shawnee a few years later. The first European to arrive (c. 1727) was a trader, James Letort, near the confluence of Crooked and Plum Creeks. In 1756, during the French and Indian War, a militia force of 30 men led by Lt. Col. John Armstrong came through on their way to attack a Native American village at Kittanning.

The first attempt at settlement was made by George Findley in 1764 in East Wheatfield. The Treaty of Fort Stanwix, New York, in 1768 made settlement legal. Fergus Moorhead and others arrived in 1772. Cherry Hill was surveyed in 1773 for the Penn family. The hostilities of the American Revolution first reached western Pennsylvania in 1777, when Andrew Simpson was killed and Fergus Moorhead was captured and taken to Canada. Charles Campbell and others were captured soon after. The first towns to be incorporated were Newport in 1790 and Armagh in 1792. Indiana County was created in 1803, and on September 7, 1805, George Clymer gave 250 acres to the first trustees.

Beginning in 1813, the manufacture of salt was the first major industry in the area. Saltsburg was founded in 1816. The industrial revolution arrived in 1828, when the first steam engines were put into use at the saltworks. Use of coal increased until 1838 and then declined slowly as the salt production diminished. The first iron foundry was functioning in Blairsville prior to 1830, and the first iron furnace began working in East Wheatfield in 1840. Rafting of timber began in 1827. Almost all other enterprises were agrarian.

Numerous towns and townships sprang up in Indiana County, including Indiana Borough, founded in 1816, and Blairsville, founded in 1818, which was the largest town in the county by 1830. The most important transportation improvement of the time was the construction of the Pennsylvania Canal, opened for vessel traffic from Saltsburg to Blairsville in 1829 and on to Johnstown by 1830. The Huntingdon, Cambria and Indiana Turnpike was completed by 1821, and another turnpike from Ebensburg to Kittanning via Indiana opened in 1823. By 1838 there were 82 schoolhouses in the county. When the Indiana Academy opened its doors in 1814, it was the county's first secondary education institution. Federalist James McCahan began publishing the county's first newspaper, the *American in Indiana*, in 1814. A Democratic-Republican paper, the *Indiana and Jefferson Whig*, appeared later and merged with the *American* in 1828. John Young of Westmoreland County was the first judge, succeeded by Thomas White of Indiana County in 1836.

Although antislavery societies had been organized by 1837, the slavery issue exploded in 1845 with the "kidnappings" of fugitive slaves near what is now Clymer. The subsequent trial of Dr. Robert Mitchell in federal court aroused citizens as never before. The slavery question infused and dominated both politics and religion. For example, the Presbytery of Blairsville had adopted a strong antislavery resolution by 1846. Active from 1853 to 1857, the American party, better known as the "Know Nothing" party, espoused secrecy and bigotry against foreigners and Catholics but held to an antislavery stance and thus attracted many supporters. Defeated at the polls, some of the Free Soil faction joined the new Republican party when it was formed in Pittsburgh in 1856, among them Dr. Mitchell, a vice president of the convention. Within a year the Know Nothings were eclipsed and the Republicans were dominant. John Fremont in 1856 and Abraham Lincoln in 1860 received large majorities in Indiana County. The first Indiana County resident to sit in the U.S. Congress was Augustus Dru, who served from 1852 to 1854.

As the coal-mining and salt industries declined, so did the activities of the iron furnaces. The local economy slumped in response. The Indiana County Agricultural Society was formed and held its first county fair in 1855. By 1851 the railroad extended into Indiana County as far as Blairsville. It reached into Indiana by 1856 and Saltsburg by 1865.

Schools were placed under the supervision of the first county superintendent, Rev. Samuel P. Bollman, in 1854. Elders Ridge Academy was established in 1847 by Rev. Dr. Alexander Donaldson, and Blairsville Female Seminary opened in 1851. A number of Indiana County men served in the Mexican War of 1846. The Civil War caused a tremendous upheaval on the local level. It is estimated that 3,680 local men (11 percent of the population) served in the Union armies. Titian J. Coffey served in Pres. Abraham Lincoln's administration as assistant attorney general and acting attorney general.

Agriculture and timber harvesting were the chief economic activities during this period. Some of the agriculture-related industries were strawboard mills, meat packers, distilleries, flour mills, breweries, creameries, and woolen goods production. New mines sprang up in Glen Campbell between 1889 and 1890. Other industries revolved around producing glass, bricks, tuyeres, cigars, wagons, and carriages. There were also planing and furniture mills. By 1883 Sutton Brothers and Bell of Indiana was the largest iron foundry in the area. From 1887 to 1889, new railroads were reaching into the northeastern sections of the county. So far, eight bridges, each 300 feet or more long, spanned the Conemaugh River. Indiana had telegraph service by 1869, and by 1890, 21 towns in the county had telephone service. A new courthouse was completed in 1870, and a new jail in 1888.

A political upset in 1882–1883 elected Silas M. Clark to the state supreme court and John Patton to the U.S. Congress; both were from Indiana. The Indiana State Normal School was established in 1875. The first written history of Indiana County, the work of Christopher T. Arms and Edward White, was published in 1879. The inception of the Women's Christian Temperance Union in 1881 is said to have been the first step toward equality for women.

This was the era of "King Coal." By 1915 there were 53 mining companies in operation, each with 20 or more employees, and 115 mines. Coal production from 1891 to 1900 was 5,386,004 tons; from 1901 to 1910, 49,709,424 tons. The two largest companies were the Rochester and Pittsburgh Coal and Iron Company and the Clearfield Bituminous Coal Corporation. New coal towns sprang up: Glen Campbell first; Rossiter in 1900; Ernest in 1902; Iselin in 1903; Heilwood in 1904; Clymer 1905; Lucerne in 1906, McIntyre in 1910; Aultman in 1912; and numerous others. Coke ovens were built at Coral-Graceton and Ernest. There were disasters at Ernest in 1910 and 1916 in which 37 men died. The United Mine Workers of America was organized. There were strikes at Glen Campbell mines in 1894 and 1899, and at mines in Ernest in 1906, where one man died.

The advent of the coal boom stimulated the growth of other industries and establishment of new companies. Among them were the Indiana Foundry Company in 1899; a reorganization of Sutton Brothers and Bell; Homer City–based Prairie State Incubator in 1887; Clymer Brick and Fire Clay Company in 1907; McCreary Tire and Rubber Company in Indiana in 1915; Garfield Fire Clay Company in Robinson in 1899; Indiana Bent Rung Ladder Company in 1891; Indian Brewing Company in Indiana in 1904; Clymer Manufacturing Company (later Penn Enamel Sink Company) in Indiana in 1902. A number of glass companies were established in Blairsville and Indiana, and electricity-generating plants grew up in both towns in 1890 and 1891. Two large iron furnaces were built in Josephine 1907 and 1912. The Blairsville Rolling Mill and Tin Plate Company went into business in 1892. A new fairgrounds was developed in 1892, and the Pennsylvania State Fair was subsequently held there. By 1896 the last commercial rafts had left Cherry Tree.

In 1908 there had been only two state-certified high schools, Blairsville and Indiana, but there were eight by 1912. Elders Ridge Vocational School replaced Elders Ridge Academy in 1914. Blairsville College for Women closed in 1913. The Indiana State Normal School grew. Serving 659 students in 1893, it had 1,500 students and 54 faculty by 1915. The first motion pictures were seen in 1896, before the advent of the nickelodeon in 1907. The largest theater in 1904 was Blairsville's Einstein Opera House. The county "poor house" was built in 1908. Cherry Tree's citizens erected the Fort Stanwix Treaty monument in 1894. Two more county histories were published: Samuel T. Wiley's 1891 *Armstrong and Indiana Counties* and J.T. Stewart's two 1913 volumes.

Trains were the beasts of burden for the coal industry, and railroads were being built all over Indiana County. The Buffalo, Rochester and Pittsburgh Railroad was active from 1902, and the New York Central from 1903. By 1903, automobiles were beginning to be seen, but there were only six of them registered in the entire county. Construction of a streetcar system from Indiana to Ernest and Clymer began in 1906 and was completed as far as Blairsville by 1910. An airplane was seen for the first time at the county fair in 1912.

The most scandalous election in Indiana County history occurred in 1894, when Harry White and John P. Blair ran against each other for a judgeship. Bribery, whiskey "treats," and other chicanery were rampant. Harry White won narrowly but was defeated for a second term in 1904. Whiskey Run was infamous for 22 murders. In 1904 John P. Elkin was elected to the state supreme court.

World War I called many to service. Anthony Caputo of Starford was the first from the county killed in action. Selective Service required 11,354 local men to register, and more than 1,000 were drafted. Clymer had more enlistments in proportion to its population than did any other town in the county. Pennsylvania National Guard members of Company L, Blairsville, and Company F, Indiana, lost 95 men who were killed in battle. In 1919 the Victory Arch was erected in Indiana. Prohibition, with its moonshining, bootlegging, and other crimes, did not leave the county untouched. There were bank robberies and a streetcar payroll robbery in 1924. A mining disaster in Clymer took the lives of 44 miners, the worst in Indiana County history.

Streetcar service had ended by 1933, and the Pennsylvania Railroad discontinued passenger service in 1940. The 1936 flood took lives and destroyed bridges and property. Strip mining commenced in 1917. The Ku Klux Klan was very strong during the 1920s. An estimated 50,000 people were said to have attended a huge Klan rally that took place near Cookport in 1924. There were 10 Klan lodges in Indiana County. The Klan purchased land between Indiana and Homer City, where one of its rallies attracted 20,000 people. A new Klan hall under construction in 1925 was blown up and burned. A strike in Rossiter made national headlines. Families were evicted from their homes. Coal and iron policemen known as "pussyfooters" beat and injured a man in his own home in 1928. Judge Langham prohibited church members from singing when nonunion "scabs" passed by. A committee of the U.S. Senate condemned these things "a blotch upon American civilization."

A concrete road, possibly the first, was built from Indiana to Homer City in 1921. By 1928 there were 15,735 registered automobiles. The Brae Breeze airfield, built in Marchand in 1918, was apparently the first one built in the area. Indiana had two ornate theaters, the Ritz and the Indiana. The normal school came under state control in 1919 and was renamed Indiana State Teachers' College. One of the first women to hold public office was Dollie Walker Ayers, who was elected to the office of register and recorder in 1924. In 1932 the Welfare Association of Indiana County was formed, and families with an income of $2.50 per week or higher were prohibited from receiving aid. Thirty-two percent of the population was receiving emergency relief. After the Roosevelt New Deal took effect in 1934, 27 federal work projects gave employment to many. Among the local projects were road building, the construction of a Boy Scout mess hall from stone, and an addition to the National Guard Armory in Indiana. A dam at Rochester Mills was built and renovation undertaken at several schools and at Indiana State Teachers' College. A reservoir was constructed in Homer City; a municipal hall was built in Cherry Tree; and Memorial Hall in Blairsville was erected. Sewer lines were laid, and old mines were sealed.

By 1935 the county owned 26 percent of all taxable real estate consisting of 3,800 parcels, but by 1937 the local economy was beginning to recover. Records show that there were 197 industries in 1922 manufacturing 46 kinds of products valued at $32,195,000. John W. Warner, Indiana County Farm Bureau agent since 1918, had a great influence guiding farmers to raise more and better crops. The Crooked Creed Soil Erosion project in 1934 involved 458 farms and was the first in Pennsylvania. Two Civilian Conservation Corps camps in Rayne Township and near Shelocta expedited the soil-erosion projects. The rural electrification project, organized under the guidance of S.J. Orange in 1936, built the first 15 miles of line in 1938. The Historical and Genealogical Society of Indiana County was organized in 1938 by Frances Strong Helman and others.

World war loomed in 1940. County enlistments increased, and one of them was James Stewart. Draftees were inducted every month in 1941. Air observation posts were set up and manned by American Legion volunteers. Several Indiana County men were at Pearl Harbor on December 7, 1941, but only one, George Tillett, was injured. It is believed that he was the nation's first casualty in the conflict. Numerous communities set up honor scrolls of local servicemen and servicewomen, and by 1943 the large scroll at the courthouse had accumulated 7,100 names. Schools conducted salvage drives, and students picked elderberries and milkweed pods. Because of labor shortages, some farmers shifted from dairying to beef cattle and sheep. The government took over the mines in 1943. There were very few local war industries. McCreary Tire and Federal Laboratories were among the few in the county. The population in 1943 was 17,649 less than in 1940. All major sports, the Indiana State Teachers' College homecoming, and the county fair were cancelled. When the war ended, about 2,000 people became almost immediately unemployed.

The following enumeration indicates some of the technological and cultural advances that the county experienced over the years. WDAD, the first radio station, went on the air in 1945. Dial telephones came to the community in 1951. The first television was seen in Indiana in the window of Art Lewis's store in 1948. An Associated Press dispatch in the 1950s touted Indiana County as "the Christmas Tree Capital of the World," and *Fortune* magazine recognized Musser Forests as "the Biggest Christmas Tree Grower" in 1952. The local Democratic party, after many years as a minority, made advances. Two county commissioners, Dee Miller and Harold McCormick, were elected in 1955. In 1959, Indiana State Teachers' College became Indiana State College, which became Indiana University in 1965. The first Amish people came to live in the northwestern section in 1961. Artist Linton Park received posthumous recognition in 1951, when his paintings were reproduced in *Life* and *National Geographic*. Jimmy Stewart returned home to fame after making the films *It's a Wonderful Life* in 1946 and *Harvey* in 1950. The first of three giant electric plants was completed in 1967. New county parks were developed beginning in 1965, and Yellow Creek State Park was constructed in 1967. A new courthouse was built in 1970 and the old one leased to National Bank of the Commonwealth in 1973. The *Gazette* erected its own new building in 1969 and installed an offset press.

In 1951, a highway bypass was constructed around Blairsville. Hamilton Airfield closed in 1950 but was replaced by Jimmy Stewart Airport. District justices replaced justices of the peace in 1969. Forty school districts in 1945 had merged into seven by 1966. By 1970 the population had recovered to the 1940 level. Among the problems during this time was an economic decline that had began immediately after the war ended, resulting in a loss of population. From 1940 until 1960, population declined by 4,488. Former industries closed, among them Jiffy Steak Company, Greiner Bakery in 1960, all coke ovens by 1971, and the Indiana Foundry in 1957. The Clearfield Bituminous Coal Corporation had closed or sold all its mines by 1953, including those at Commodore and Clymer. Pennsylvania Railroad ended passenger service from Blairsville to Saltsburg and passenger service from Clymer to Cherry Tree in 1947. All passenger service in the county ended when the Baltimore and Ohio Railroad ended service from Punxsutawney to Indiana in 1950. The rail yard at Blairsville was closed in 1967. The Indiana Hotel was destroyed by fire in 1962, and the Moore Hotel burned in 1966 with the loss of one life.

The Korean War killed a number of local servicemen and injured others. The Vietnam War divided people as never before. Large numbers of people, particularly Indiana University of Pennsylvania students, resorted to protests that sometimes resulted in violence. Today, Indiana University of Pennsylvania is the largest employer in the county, with about 1,800 employees, and the largest of the 14 state universities, with about 13,800 students. Farming is again the number-one industry, with tourism coming in second.

—Clarence D. Stephenson

One
THE INDIANA AREA

This log house was built in the early 1800s in Shelocta and was originally the home of Abner Kelly. In 1961 it was moved and reconstructed on the Historical and Genealogical Society of Indiana County property and became a part of the society's museum. Dedicated on June 30, 1962, it serves as an example of pioneer life in memory of all pioneer forefathers.

CAMP "REST-A-WHILE"
FOTO BY DOUGLASS

In 1920 a group of Indiana men purchased a parcel of land located on Indiana Springs Road. They named this tract Camp Rest-a-While, a place where they could gather and enjoy social outings. By 1924 a swimming pool had been added, and memberships were sold to other Indiana citizens. It is currently home to the White Township municipal building.

New, Indiana House, Indiana, Pa.

Thomas McCartney had an inn at the southeast corner of Philadelphia and Sixth Streets, and by 1832 Charles Kenning had a hotel here as well. David Ralston and William Moorhead were owners of this hotel, known as the Indiana House during the 1840s. By 1866 this four-story hotel was the largest in Indiana. Years later a fifth story was added, but a disastrous fire in 1962 ruined the upper four floors.

The Indiana Country Club was incorporated on July 7, 1919, and is the oldest golf course in Indiana County. It was located on the former Alexander Litzer farm in White Township just north of Indiana on old Route 119. In 1945 Earl E. Hewitt Jr. of Indiana defeated Arnold Palmer of Latrobe for the club championship.

In 1894 the Girls' Industrial Home, located in Indiana, was under the care of the Children's Aid Society of Western Pennsylvania, which purchased the Major McFarland home at Eleventh and Washington Streets for $5,000, including one acre of grounds. Sue Williard served as the overseer, whose charge was to train girls in housekeeping, give them a good school education, and place them in good homes. It serves as a private housing complex today.

McCreary Tire & Rubber Co. - Indiana, Pennsylvania

Harry McCreary started his tire business at the age of 50, following a successful career in the coke industry. His 50- by 150-foot one-story building was completed in 1915. It grew to a 200,000-square-foot facility by 1966, producing 100 passenger and light truck tires and 400 heavy-duty truck tires daily and employing 400 people. On July 3, 1992, it became Specialty Tires of America Inc. and currently employs 300 people.

Dugan Glass Works, County Home in background, Indiana, Pa.

The story of glassmaking in Indiana began in 1892, when the Indiana Glass Company was formed. In 1896 it became the Northwood Company, in 1899 the National Glass Company, and in 1904 the Dugan Glass Company. In 1913 it became the Diamond Glass Company, making high-grade decorative tableware, novelties, and iridescent glassware. At its peak in 1907, the company employed 200 people, but it never reopened after a disastrous fire on June 7, 1931.

Sixth Street North
from Water Street,
Indiana, Pa

This view of the Sixth and Water Streets intersection in Indiana shows a trolley owned by the Indiana County Street Railway Company. Formed on July 23, 1907, this company ran lines to Blairsville, Creekside, and Clymer. As the automobile became more popular, ridership on the trolleys declined, and the last day that cars ran was June 30, 1933. The building on the right, the former Clawson House, is now the Brown Hotel.

FORD V-8 FOR 1936

Every feature of the new Ford car measures up to the standard of its V-8 engine. We invite you to drive this modern car and to examine its many fine-car features.

Using an older model as the down payment, one could buy this new 1936 Ford V-8 for $25 a month from the Sutton-Miller Ford Agency in Indiana. Opened in 1911, this Ford dealership moved into a new four-story building on South Sixth Street in 1922. A large elevator moved cars among the floors. Sutton-Miller sold out to Lewis and Weston McGill in 1945.

The Robinstein Collar and Leather Company was located at 300-348 Philadelphia Street in Indiana. It began operations in 1907 and handled the tanning of leather as well as the manufacture of horse collars. With the increase in the number of automobiles and tractors in the area, the demand for horse collars dwindled, and the firm closed its doors in 1936.

Built in 1867, this was the residence of Judge Silas M. Clark. He became a member of the Indiana County Bar in 1857 and later became a judge on the state supreme court. Located at 200 South Sixth Street, Indiana, the building now serves as the headquarters of the Historical and Genealogical Society of Indiana County.

The Rochester and Pittsburgh Coal and Iron Company was organized in 1881. In 1921 the offices of the company were moved from Rochester, New York, and Punxsutawney, Pennsylvania, into this new building at 655 Church Street, Indiana. At one time the company operated mines at Ernest, Lucerne, McIntyre, Aultman, Iselin, Coy, Tide, Snyder, Waterman, Luciusboro, and Coal Run.

After merging with the Neal and Simpson Hospital in 1913, the Indiana Hospital continued operating at Ninth and Church Streets until its new facility opened on October 29, 1914, next to the Indiana Fairgrounds. Adrian Iselin donated $125,000 for the first building, designed to treat 45 patients. In 1929 a new wing was built, increasing the bed capacity to 154. The Mack wing, dedicated in 1938, enlarged the hospital's capacity to 200 beds.

17

Rustic Lodge of 2199 Oakland Avenue, Indiana, was founded by Leslie Pattison in the late 1920s. The main log building housed the restaurant, with a picnic shelter and dance hall nearby. Tony Ricupero acquired this lodge in 1947 and immediately began improving and enlarging the restaurant and banquet facilities. Its banquet rooms are capable of serving up to 750 people at a time.

This Second Ward Public School, also called the Horace Mann School, was built on South Fifth Street, Indiana, next to the old public school that it replaced. The beautiful school cost $76,539.39 to build. It contained 16 classrooms, a large rotunda hall, a library, a gymnasium, and offices. It opened on February 1, 1909, and was dedicated on February 19, 1909, with the Honorable John P. Elkin, justice of the state supreme court, delivering the address.

The original Indiana County Courthouse was built in 1808 and was torn down in 1868. The second courthouse in Indiana, pictured here, was finished in 1870 at a cost of $150,000. It was located at the corner of Philadelphia and North Sixth Streets with a water fountain out front, donated by the Women's Christian Temperance Union. It also contained the largest clock in the county at that time, which required a 15-minute weekly winding by a custodian.

The Marshall Building was located at the corner of Philadelphia Streets and Carpenter Avenue in Indiana. In 1923 John P. Elkin's widow, Adda, purchased the building with the intention of building a theater there. After extensive remodeling efforts, the Indiana Theater opened on July 16, 1924. John P. Elkin's son Stanley was its manager, and George McGown was the managing director.

This is the Philadelphia Street and Carpenter Avenue location where the Marshall Building once stood. It was replaced by the Diamond Drug, Indiana Theater, and Campus Grill buildings. The Indiana Theater had two balconies, a well-equipped stage, and a large crystal chandelier that sparkled like diamonds. It seated 1,100 people.

In earlier days, the Indiana Theater shown here not only ran silent films accompanied by the theater's own full-time orchestra, but it also used the auditorium on Thursdays, Fridays, and Saturdays for stage shows. For a while, four weekly vaudeville acts were presented in conjunction with the silent films being shown. Edgar Bergen, the famous ventriloquist, appeared here with his dummy, "Charlie McCarthy," in the late 1920s.

"SPIRIT SLATE MYSTERY" from NEFF'S MODERN MIRACLES.

The Ritz Theater, located at Philadelphia Street and Taylor Avenue in Indiana, opened in 1924. Bill Neff, a master magician and an Indiana native, was a frequent guest on the Ritz stage. Hollywood film star and Indiana native Jimmy Stewart actually made his first stage appearance as a professional with his good friend Bill Neff in one of Neff's shows at the Ritz. Jimmy Stewart graduated from Princeton University in 1932 with a degree in architecture. In 1940 he won an Academy Award for his performance in *The Philadelphia Story*. His Oscar was on display for 20 years in his father's hardware store. Jimmy Stewart joined the U.S. Army Air Force on March 22, 1941, and his war record was the most distinguished of any movie star of his time. He participated in 20 bombing raids over Germany during World War II. In September 1959, President Eisenhower appointed him a brigadier general in the U.S. Air Force Reserves. After starring in scores of movies and gathering many awards and accolades, he died on July 2, 1997.

This postcard, mailed in November 1954, shows part of the main business district of Indiana. Located next to Brody's was the G.C. Murphy Company, one in the small chain of five-and-dime stores that became successful. J.S. Mack of Brush Valley acquired a controlling interest in the G.C. Murphy Company in 1911. With the profits of his endeavors, he set up the J.S. Mack Foundation in 1943 and bought the Indiana Fairgrounds for local citizens to enjoy.

The Buffalo, Rochester and Pittsburgh Railroad depot still stands at 1125 Philadelphia Street, Indiana. With the Indiana Band playing, whistles blowing, and 1,000 townspeople cheering, the first passenger train of the Indiana Branch of the Buffalo, Rochester and Pittsburgh Railroad pulled into this station on May 2, 1904. Eventually the Baltimore and Ohio Railroad took over the station. Recently restored, it now houses the Train Station Restaurant.

Veterans of Foreign Wars Club House, Indiana, Pa.

The Indiana Veterans of Foreign Wars Post 1989 was chartered on December 19, 1931 with 81 original members. It grew to 650 regular members and 400 social members by 1953. In 1938 the group purchased this clubhouse, remodeled it, and in 1942 moved in. It was during the remodeling phase that the nine-hole golf course was completed. Within 20 years another nine holes were added.

Philadelphia Street, Showing Portion of Business Section, Indiana, Pa.

This photograph of Philadelphia Street was taken before April 2, 1940. On that day, the Indiana Borough Council decided to try an experiment. It voted to install 269 parking meters "to help in the control of traffic in Indiana Borough." The experiment worked, and by 1953 there were 702 meters installed in the borough.

The McFarland Foundry, at 1051 Philadelphia Street in Indiana, became the Clymer Manufacturing Company in 1901. Two years later, a new building, 40 by 120 feet, was constructed at a cost of $10,000. Sinks and lavatory fixtures were its main products. In 1909 the company employed 50 men. On July 18, 1910, the plant was leased by Byron Stewart and George Conrath, and it became the Penn Enamel Sink Company.

In 1904 the Buffalo, Rochester and Pittsburgh Railroad completed its rail route from Buffalo to Indiana. It was built to provide a direct route to Buffalo and Rochester, where coal was then reshipped to markets along the Great Lakes and in Canada. This magnificent steam engine, No. 145, is from its fleet. One can see why they were called iron horses. The railroad was sold to the Baltimore and Ohio Railroad in 1932.

Philadelphia Street West from Pennsylvania Railroad, Indiana, Pa.

The A.M. Stewart and Company store was erected in 1853 by James and Peter Sutton, W.B. Marshall, and Archibald M. Stewart at Philadelphia and Eighth Streets in Indiana. From 1879 to 1883, James Maitland Stewart conducted the firm under the name A.M. Stewart and Company. In 1880 W.B. Kline and W.B. Marshall built a dry goods store adjacent to the Stewart hardware store.

James Maitland Stewart was joined by his two sons, Alex and Ernest, in operating his hardware business in the early 1900s. This building was gutted by a disastrous fire in 1912. A three-story replacement structure featured large plate-glass show windows and a brownstone front. Alex bought his brother out in 1912 and operated his hardware store here until it was demolished in 1969. S & T Bank now occupies the site.

The Buffalo, Rochester and Pittsburgh Railroad operated the Comet, shown in this postcard scene mailed April 24, 1914, from Creekside, Pennsylvania. Rail motor car No. 1001 was first operated on the Buffalo, Rochester and Pittsburgh Railroad on May 19, 1910.

The citizens of Indiana wanted to honor their veterans who had served in Word War I, so they constructed this arch over Philadelphia Street in 1919. Behind the arch on the right is the Moore Hotel, and on the left under the arch is what was known as "the big warehouse"—J.M. Stewart and Company, owned by Jimmy Stewart's father, Alex.

Business must have been very good at these enterprises, located on Philadelphia Street between Seventh and Eighth Streets. Almost every parking space is taken in this late-1930s view. Shown are Owen's Market, the Indiana Community Center (the old YMCA building), the Indiana Evening Gazette building, the Pennsylvania Railroad station, the Moore Hotel, and the Elks building.

In 1904 the Shryock Hill Brewing Company began construction of this building at the corner of Oak and Eleventh Streets. Shortly thereafter, the name was changed to the Indian Brewing Company. A 1907 advertisement claimed lager beer was a "tonic" that "tones up the nervous systems, restores wasted tissues, nourishes and invigorates both body and brain." In 1907 the brewery employed 35 people with an annual payroll of $45,000.

Indiana County Jail, Indiana, Pa.

The first jail in Indiana was erected in 1807 at the corner of Sixth and Clymer Streets and was used until 1840. A second stone jail was then built on the site behind the old courthouse. It stood until 1887, when it was demolished and replaced on the same site by the third jail in 1888, pictured here. Its location was at Sixth Street and Nixon Avenue, and it was connected to the old courthouse at Sixth and Philadelphia Streets. It was built at a cost of $50,793.73.

Philadelphia Street, looking West, Indiana, Pa.

Can you imagine Philadelphia Street without automobiles? Only six cars were registered at the Prothonotary's Office in Indiana by 1906. One of these belonged to J.R. Stumpf of Indiana. Stumpf had the first five-and-dime store in Indiana, and on July 24, 1901, he announced he would deliver goods by means of a mobile steam auto. He would often bring his steamer out front of his store in the 700 block of Philadelphia Street and run it to attract crowds.

The organization of the Zion Lutheran Church began in 1813, with Rev. Johann Lamprecht preaching monthly. Christian Rugh and Conrad Rice were the first elders. A red brick edifice was constructed in 1831 at Church and Clymer (Sixth) Streets, where the present parsonage is now, and the building was used until 1880. In 1881 the church pictured here was dedicated and served until 1923. The present building was dedicated in 1924.

This scene of Philadelphia Street, looking west from Sixth Street, was probably taken in 1953. Some of the businesses recognizable on the left include the Blair F. Uber record shop; the Capitol Restaurant; Blatt's Auto and Hardware; and Montgomery Ward. On the right are Indiana Office Supply; Sears, Roebuck and Company; Campus Grille; the Indiana Theater; Diamond Drug; Saving and Trust Bank; Dairy Dell; G.C. Murphy Company; and Brody's.

The St. Bernard congregation was founded in 1847, and a small frame church was erected at Oak and Fifth Streets. The parish was under the care of St. Vincent Monastery in Latrobe. This new church, built on Fifth Street, was dedicated on September 28, 1871, with the rectory being started in 1875. They remained in use until the present St. Bernard of Clairvaux Church was built in 1978.

The Third Ward Public School, located in West Indiana near the Indiana State Normal School, was completed in 1871. It originally consisted of four rooms, and four more were added in 1889, with additional space added in 1922. It was renamed Thaddeus Stevens School in 1931. Indiana University of Pennsylvania acquired the building in 1962, remodeled it extensively, and renamed it Uhler Hall.

Indiana became a borough in 1816. This bird's-eye view of the First and Second Wards 90 years later shows how much it had grown. Church spires, beautiful homes, and the courthouse are all visible in this postcard view published by H.H. Brilhart of Indiana. The population of Indiana totaled 14,895 in the 2000 census.

By the time this card was mailed in 1912, most horse-drawn vehicles had disappeared from Philadelphia Street, and automobiles had appeared. Here a fine old touring car is parked on the north side of Philadelphia Street between Seventh and Eighth Streets in front of the Elks building.

Shown here is the north door of John Sutton Hall, the main building of the Indiana State Normal School. In fact, for 18 years it was the only building on the campus. It contained classrooms, auditoriums, dormitory rooms, laundry facilities, a dining room, a library, a chapel, a presidential suite, and so on. It has been recently remodeled and contains many administrative offices, as well as the beautiful Blue Room for formal receptions.

North Door of Main Building State Normal School, Indiana, Pa.

Main Building, State Normal School, Indiana, Pa.

The first building erected at the Indiana State Normal School in 1875 was John Sutton Hall, named after John Sutton, the first president of the board of trustees. In 1920 the Commonwealth of Pennsylvania assumed ownership and control of this normal school. The name was changed to Indiana State Teachers' College in 1927. It became Indiana State College in 1959 and Indiana University of Pennsylvania in 1965.

Clark Hall (a boys' dormitory) was the second building constructed on the campus of the Indiana State Normal School. Built in 1893, it was named in honor of Silas M. Clark, a judge of the state supreme court and second president of the board of trustees. The original Clark Hall burned down on December 1, 1905, but it was replaced by 1907. This is a picture of the reconstructed hall.

"BREEZEDALE," RESIDENCE OF HON. JOHN P. ELKIN, INDIANA, PA.

Breezedale was the residence of the Honorable John P. Elkin, who served as a justice in the state supreme court from 1911 to 1915. Previously he had served two terms in the Pennsylvania legislature, served as attorney general, and was elected to the U.S. Congress in 1896. Breezedale now serves as the Indiana University of Pennsylvania Alumni Center.

A. W. WILSON HALL, (MODEL SCHOOL,)
STATE NORMAL SCHOOL,
INDIANA, PA.

Henry Hall of Indiana published this fine postcard illustrating Wilson Hall (the Model School), which was constructed in 1893. This was the third building erected on the Indiana State Normal School campus. It was named after the third president of the board of trustees, Andrew W. Wilson, an original founder and planner of the school. It was used as a training school until 1940, remodeled, and then used as the college library until 1960.

INDIANA STATE NORMAL SCHOOL
INDIANA, PENNA.

The "Greek Seats and Steps" were located on the west side of North Walk across from Wilson Hall and once led to a rose arbor opening into the Oak Grove. They were constructed under the guidance of Dr. James E. Ament, principal from 1907 to 1917. This is one example of his "neoclassical beautification efforts" on campus. Ament strove to offer students a chance to get a liberal arts education along with their teacher training.

Front Campus, State Normal School, Indiana, Pa.

This view of the front campus features Leonard Hall on the left and the Model School, Wilson Hall, on the right. Leonard Hall was erected in 1903, the fourth classroom building completed on campus. It was named after Jane Leonard, a faculty member and preceptress who had been a staff member since the opening of the normal school in 1875. It was destroyed by a fire on April 14, 1952, but was rebuilt on the same site.

STATE TEACHERS COLLEGE, INDIANA, PA. *Turgeon, Pgh.*

This view captures how the campus of the Indiana State Teachers' College looked between 1931 and 1939. In the center of this photograph are, clockwise from the right, Wilson Hall (1893), Leonard Hall (1903), McElhaney Hall (1931), John Sutton Hall (1875), Clark Hall (1893), the athletic field, and Waller Gymnasium (1927). Note the power plant at the bottom left.

The John A. Keith School Building was built under the 1936 General State Authority Program of the Commonwealth of Pennsylvania. It housed the laboratory and demonstration school (the Model School) that had been located in Wilson Hall. John E. Davis, former supervising principal of Clymer High School, became the new director of the Laboratory School.

Ground was broken in 1927 for this gymnasium (later named Waller Gymnasium), on Oakland Avenue between Tenth and Eleventh Streets. It was dedicated in 1928 as a center for the health and physical education department of the institution. It housed classrooms, offices, a swimming pool, two gymnasiums, and locker rooms. The theater department now occupies this building.

Auditorium — State Teachers College Indiana, Pa.

This auditorium was built under the 1936–1939 General State Authority Program of the Commonwealth of Pennsylvania. Officially known as the John S. Fisher Auditorium, it had a seating capacity of 1,600. It was named after John S. Fisher, governor of Pennsylvania from 1927 to 1931. He was born near Plumville, Indiana County, on May 25, 1867, and graduated from the Indiana State Normal School in 1886.

May Dance on Normal Campus, Indiana, Pa.

Swing Out Day activities began *c.* 1918 when Swing Out Day was included as part of a comprehensive commencement week finale. These activities then grew into Swing Out Week, during which a Swing Out queen and court were chosen. The main focus of Swing Out in the 1960s was a music production under the leadership of faculty members Charles Davis and Robert Ensley. During the 1970s Swing Out productions were phased out.

37

Arts Building — State Teachers College
Indiana, Pa.

After the normal school became Indiana State Teachers' College in 1927, it became apparent that additional facilities were needed for the art, business education, and home economics departments. As a result, McElhaney Hall, pictured here, was erected in 1931 between Leonard Hall and John Sutton Hall to house these three departments.

Thomas Sutton Hall was erected in 1903 as an addition to John Sutton Hall. It contained a kitchen, dining rooms, and dietitian's office on the first floor, and housing for 65 female students on the second and third floors. Thomas Sutton served on the board from 1880 to 1936. He also served from 1897 to 1936 as the fourth president of the board of trustees.

This is the magnificent view one would have encountered entering the main entrance, North Walk, to the Indiana State Normal School *c.* 1905. At that time only Clark Hall, Wilson Hall, and John Sutton Hall, pictured here to the right of Leonard Hall, existed on campus.

The grandstand and baseball field were part of Dr. David J. Waller's legacy at the Indiana State Normal School. The seventh principal, he served from 1893 to 1906. Under his guidance Wilson Hall, Clark Hall, Leonard Hall, and Thomas Sutton Hall were built. He then turned to the establishment of a major sports program and the construction of a grandstand and six tennis courts. One can see the old bell tower of Thaddeus Stevens School (Uhler Hall) behind the grandstand.

The old Indiana Spring, called the "Armstrong Spring" on this postcard, is now incorporated into the student union building of Indiana University of Pennsylvania. It was here in 1756 that Lt. Col. John Armstrong and 300 men from the 2nd Battalion, Pennsylvania Regiment, encamped on their way to destroy the Delaware Indian town of Kittanning. It was also called "Shaver's Spring" by Clarence D. Stephenson in his *Indiana County History Bicentennial Edition* of July 3, 1976.

Two
The Blairsville Area

Blairsville's first public building, this log schoolhouse, was erected at Liberty Street and North Alley in the early 1820s. It served as a schoolhouse, council room, and church in the early days. Jesse M. Bishop was the first teacher, followed by Lyman Waterman, Moses David, Martin Brainard, and Dr. M.L. Miller. Blairsville was incorporated as a borough on March 25, 1825.

BLAIRSVILLE PA. FROM BAIRDSTOWN HILL

Although Blairsville is named after John Blair, who was president of the Huntingdon, Cambria and Indiana Turnpike, the two developers were James Campbell and Andrew Brown, landowners along the Conemaugh River. Campbell's site would become the location of the bridge that would carry the new turnpike over the Conemaugh. In 1890 Brownstown would be incorporated into the town of Blairsville. By 1819 the turnpike reached the area and was made the Main Street (Market Street). The two other principal streets, Campbell and Brown, are named after the co-founders. Lots of 60 by 150 feet were laid out along Market, Brown, and Campbell Streets and were auctioned off on November 11, 1818.

Everett House, 1871, Luther Martin, Proprietor, Blairsville, Pa.

Hugh Culbertson bought the first two lots auctioned, one for $60 and the second for $85. Ten years later, in 1828, he sold them to Samuel McAnulty for $225 and built the Exchange Hotel on these lots. They were located at the northwest corner of the Diamond (the public square at Market and Liberty Streets). The Exchange Hotel was known as the best hotel between Pittsburgh and Harrisburg. McAnulty retired in 1854, and Luther Martin, who took over management of the hotel, changed the name to the Everett House. John Graff bought the hotel in 1872, remodeled it, and used it as a mercantile store.

Band Stand and Diamond Square, Blairsville, Pa.

Public School Building, Blairsville, Pa., built 1837

This public school building was constructed in 1837 and was located on South Walnut Street south of South Alley. Teachers included Martin Brainard, Brainard's nephew, Sarah Stansbury, and a Miss Pollock. The first high school in Indiana County was conducted in the school on South Walnut Street. The two-year program had 14 graduates in 1891.

NEW BLAIRSVILLE - BAIRDSTOWN BRIDGE

Bairdstown, named after James Baird (who owned land in the Blairsville area), was located on the west side of the Conemaugh River across from Blairsville. The "new" Bairdstown Bridge was dedicated on June 18, 1935, and connected these two towns. The old bridge on the left stood on abutments that were constructed for the original wooden covered bridge erected here in 1822. The wooden bridge collapsed into the Conemaugh River on January 22, 1874.

The St. Patrick's Day flood of 1936 was one of the worst floods to hit Indiana County. As is apparent in this image, Blairsville was not spared. The house pictured here was one of 18 county homes that were totally destroyed. Also seriously damaged were 183 houses. This flood was the impetus for the construction of many dams in western Pennsylvania.

This beautiful view of Stewart Street was published by J.P. Archibald of Blairsville. At the end of Stewart Street was once a park with a dance pavilion, merry-go-round, and concession stands. It lasted only a few years. Notice the light fixture over the intersection. Blairsville was the first town in the county to have electricity. The Blairsville Illuminating Company began producing electricity in December 1890.

The Einstein Opera House was built by Reuben Einstein in 1904. It was a four-story edifice containing a stage, orchestra pit, two balconies, and boxes. It could seat 1,100 people. Needless to say, it was the pride and joy of Blairsville. Minstrels were very popular at this time, and they appeared here regularly, along with traveling shows and operas. On May 2, 1907, William Jennings Bryan lectured on its stage.

The first Methodist church built in Blairsville was constructed in 1828 on South Liberty Street. A second one was built in 1847, and a third was dedicated on November 9, 1860. The congregation's fourth church was this massive stone edifice constructed at South Walnut and Brown Streets in 1889. On July 30, 1975, this church was destroyed by a fire that caused $625,000 in damages, making it the worst fire in Blairsville up to that time. The building was later replaced.

East Market Street, Blairsville, Pa.

On March 4, 1807, the Pennsylvania legislature authorized the construction of a turnpike from Harrisburg to Pittsburgh by the Huntingdon, Cambria and Indiana Turnpike Road Company. When it became known in 1818 that the turnpike would cross the Conemaugh River on land owned by James Campbell, Blairsville was born. Blairsville was named after John Blair of Blair's Gap, who was president of the turnpike company. Market Street followed the turnpike route.

PENNSYLVANIA R. R. DEPOT, BLAIRSVILLE, PA.

On April 6, 1850, the Pennsylvania legislature authorized the Pennsylvania Railroad Company to build a line from Libengood's Summit to Blairsville. On February 26, 1851, land for a station was obtained from William Maher for $200. On December 10, 1851, the locomotive *Henry Clay,* along with a passenger coach, steamed into Blairsville. By 1852 this station for passengers and freight had been constructed at the corner of Market and Liberty Streets in Blairsville.

Pack Saddle Gap, Blairsville, Pa.

In this view of the Pack Saddle Gap of the Chestnut Ridge of the Allegheny Mountain Range, two forms of transportation are illustrated. Navigation on the Conemaugh River was not extensive, although the Pennsylvania Canal used part of the river for transportation purposes starting in 1929. This section of the Conemaugh River was very dangerous, and boat wrecks were common. Note the coal-fired steam locomotive pulling passenger cars.

The main line of the Pennsylvania Canal operated through Blairsville from 1829 to 1863. For years afterward, the old boatmen held reunions. This fine old postcard by S.H. Shepley, postmarked 1908, depicts the Blairsville Band leading the reunion attendees down Market Street. The last reunion was held in 1915 in Johnstown. Note the Yee Quong Lee Laundry on the left.

48

Triece's Mill and Ranson's Residence, North of Blairsville, Pa. 1870

The Henry Triece Mill was erected in 1854 near Blairsville along Triece's Run (Sulfur Run). This mill burned in 1859 but was rebuilt by Triece in 1860. In 1880 it was run by a 40-horsepower steam engine, which could grind 100 bushels of wheat and 75 bushels of chop per day. Later a roller process was installed, and it became the Blairsville City Mills, turning out 125 barrels of flour daily.

Blairsville was founded in 1818 and soon grew to be the largest town in Indiana County. The iron bridge was erected 1874. Coal Hill was on the Bairdstown side of the Conemaugh River in Westmoreland County. Note the bandstand next to the McKinley monument on Market Street up from the bridge.

The Blairsville Female Seminary was founded on March 5, 1851, by Rev. George Hill. A brick building was erected in 1852 on the site of the former high school at North Walnut Street. In 1895 the name was changed to Blairsville College for Women, which closed in 1913.

The Columbia Plate Glass Company of Blairsville was the largest and most successful glass plant in Blairsville. One million dollars had been invested in this plant, and by 1906 it was making three million square feet of plate glass a year. In 1913 it employed 300 people who lived in 40 company-owned double brick buildings. The president of the company at that time was J.P. McKinney.

The West Penn Glass Company built this two-story brick plant in 1890. In June 1894 the Whitney Glass Company of Philadelphia purchased the plant after Blairsville raised $12,000 in capital to secure it. The company failed, and the Hen-E-Ta-Bone Company took over. It made agriculture-related products. In 1913 E.J. Fuchs was its president, A.K. Fuchs its treasurer, J.F. Altimus its superintendent, and A.G. Fuchs its manager.

On June 1, 1853, an application was made to the General Assembly for a charter for the Blairsville Trust and Savings Company, but the charter was never granted. On March 13, 1865, the National Bank of Blairsville was formed with William Maher as president. It later became known as the First National Bank. This bank merged with the Blairsville Savings and Trust Company in 1928, which erected this building at Market and North Walnut Streets.

Campbell's Mill Park was a popular recreation area located on Black Lick Creek. After 1900 it was noted for its swimming, camping, picnicking and dancing facilities. The park consisted of cabins, playground equipment, a dance hall, and a skating rink. In 1923 a new bathhouse was erected. This park and mill were destroyed by the 1936 flood.

Charles Campbell settled here *c.* 1772 and erected the first mill in 1780. The mill burned in 1813. It was not in Blairsville but on Black Lick Creek at the former Black Lick post office site, the second post office in Indiana County, which opened in July 1809. The rebuilt mill was powered by an overshot waterwheel. Both the mill and the milldam were destroyed by the 1936 flood.

Birdseye View of Saltsburg, Pa.

Commercial production of salt was begun in 1813 by William Johnston on land at the junction of the Conemaugh and Loyalhanna Rivers in Westmoreland County. The salt industry flourished and resulted in the formation of a new town, Saltsburg, in the fall of 1816 by Andrew Boggs, whose wife was William Johnston's sister. Saltsburg was located at the intersection of the Conemaugh and Loyalhanna Rivers, which form the Kiskiminetas River on the Indiana County side. Boggs began selling lots in Saltsburg on November 4, 1816. By 1830 there were about 21 saltworks within two miles of Saltsburg. The post office opened on May 9, 1826, with Philip Meckling as postmaster, and Saltsburg became a borough in 1838. The picture below was taken from the bluff overlooking Saltsburg where the Kiskiminetas Spring School, a boys' preparatory school, is located.

KISKIMINETAS SPRINGS SCHOOL, SALTSBURG, PA. McClaran Drug Store

On March 3, 1840, a charter was granted for the construction of this covered bridge over the Kiskiminetas River at Saltsburg. The two-lane covered bridge was completed during the summer of 1843. It consisted of two 100-foot spans, each resting on a pier in the middle of the river. The cost of construction was $10,000. It withstood the Johnstown flood of 1889, became toll-free in 1883, and burned down on June 8, 1922.

This Market Street view in Saltsburg portrays students in front of their eight-room buff brick school, erected in 1911. The Works Progress Administration, a federal program, did extensive renovations at the Saltsburg High School in 1936, including "resurfacing 200 desks, landscaping, removal of four old hot-air furnaces and surrounding brick wall, cleaning and repainting 22 rooms and hallways."

Four people drowned and hundreds were homeless after the St Patrick's Day flood of 1936. Damage was extensive ($929,245) in Indiana County. Although this bridge in Salsburg survived, the Works Progress Administration announced it would reconstruct a bridge over the Conemaugh River. Workers numbering 85 were removing litter, pumping out cellars, and spreading lime to prevent infection. As a result of this flood, the Conemaugh Dam was erected and completed in 1953.

No. 731. Rolling Mill, Saltsburg, Pa.

Construction on the Saltsburg Rolling Mill began *c.* 1894 with production expected to begin on May 15, 1895. This mill had two furnaces, one bar mill, four 48-inch-diameter boilers, an engine with a 58-inch-diameter flywheel, and 200 employees. Prior to April 1901, it had been shut down but was being overhauled before resuming production again. Indiana County produced 66,611 tons of iron in 1908.

"Saltsburg Now in Line For Hospital" was a November 1908 news story after Dr. E.B. Earhart of Saltsburg purchased the Rumbaugh homestead from Elizabeth Martin for $3,200. This was to be the fourth hospital in the county and was expected to open on August 15, 1909. By 1913 the Saltsburg General Hospital could accommodate 35 patients. Dr. Earhart died on January 8, 1914, and the hospital closed shortly thereafter.

In 1865 the Pennsylvania Railroad leased the Western Pennsylvania Railroad and in 1870 formed the Western Pennsylvania Division. By 1875 the following stations were located along its westward route from Blairsville: Snyder, Livermore, Tunnel, Kelly's, White, and Saltsburg. After crossing the river, it continued to Pittsburgh. By 1879 two trains arrived at this station daily. By the 1950s rail service was suspended to Saltsburg.

This Point Street view in Saltsburg provides a picture of the McPhilimy Furniture and Undertaking establishment, the Patterson Milling Company, and the Saltsburg House. The Patterson Milling Company building was erected in 1880 by M.V. Patterson. It was rebuilt after a 1911 fire destroyed the mill. By 1913 this mill could produce 125 barrels of its Golden Leaf flour a day.

Salt Street was at one time an appropriate name for a street in Saltburg, but by the time this image was captured, the salt industry was gone. The R.A. Steele harness and repair shop, with the horse and buggy out front, probably disappeared in a few years as well, after automobiles appeared in the early 1900s.

57

One of the first deeds (*c.* 1817) made by Andrew Boggs, the founder of Saltsburg, was to "the congregation at Saltsburg." This Presbyterian congregation appealed for a minister, and on November 9, 1817, Rev. Samuel Porter of Congruity, Pennsylvania, moved here and held his first service. The Presbyterian Church in Saltsburg was born. This postcard, postmarked 1910, shows Rev. G.M. Ryall in his role as minister.

The first house in Saltsburg was erected in 1819 at the rear of the site occupied by the Presbyterian church. John Williams opened the first tavern in 1820, and John Carson was the first tailor *c.* 1827. George Johnston became the first merchant in 1829, and Daniel Davis was the first blacksmith. A small school was started in 1831 in a little log house by Abner Whittlesey, the first teacher.

Black Lick is located in Burrell Township on Route 119. The *Indiana Weekly Messenger* reported on February 20, 1861, that "lots were being laid out at Blacklick Station for the new town of Blacklick City." Lots were to be sold on March 12, 1861. The town was founded by James Gardner and was named for a salt lick on Black Lick Creek. Its post office opened on April 2, 1906, with M.C. Fair serving as postmaster.

This postcard was mailed on Valentine's Day of 1911 and shows the First National Bank building of Black Lick, which also housed Shrum's Drug Store. This bank was chartered in November 1906 and liquidated on March 31, 1919. Since this was a National Bank (charter No. 8,428), it issued $217,600 worth of national currency, of which $35,400 was still outstanding when the bank closed in 1919.

Birdseye View of Josephine, Pa.
Jos. A. Shrom, Pub.

Iron furnaces were erected in Josephine in 1906 and 1912 and were operated by Corrigan, McKinney and Company of Cleveland. The area was named for Josephine Burke McKinney, wife of one of the partners. Daily output was 650 tons of pig iron. Approximately 190 houses existed in 1913, equipped with water and electricity. It was reorganized in 1918 as the McKinney Steel Company. Production ceased in 1936, and everything was razed.

WHERE THE ELDERSRIDGE ACADEMY STARTED, ELDERSRIDGE, PA.

The beginning of the famous Elders Ridge Academy started back in 1839, when John McAdoo took lessons from Rev. Dr. Alexander Donaldson. Other students began taking lessons, and as these sessions grew in popularity, Donaldson decided on April 16, 1847, to open an academy. He did so in the upper story of this log springhouse. In 1849 a woman's department of the academy opened under the direction of Martha Bracken.

Three
THE HOMER CITY AREA

Homer City, located at the junction of Two Lick and Yellow Creeks, was planned by William Wilson in 1854. He named it after the Greek poet Homer, but the post office was known as Phillips Mills. It became a borough on June 13, 1872. It now has a population of 1,844, the third largest town in Indiana County. Only Indiana and Blairsville are larger in size.

Homer City National Bank, Homer City, Pa.

The Homer City National Bank was established on July 20, 1907, with a capital stock of $50,000. The first board of directors consisted of E.J. Miller, president; J.L. Nix, vice president; and members C.M. Lingle, F.C. Betts, J.J. Campbell, J.A. Klingensmith, and W.P. Risinger. Located at 34 North Main Street, Homer City, it is now a Savings and Trust Bank of Indiana branch.

Main Street, showing the Homer National Bank and Empire Theatre Building, Homer City, Pa.

The Homer City National Bank, founded in 1907, is seen to the right. A new three-story building was erected in 1909. The bank went into receivership on June 12, 1936. It became the Homer City State Bank in 1939 in the same building. It merged in 1985 with the Savings and Trust Bank of Indiana. The Empire Theater (left) was opened in 1913 by E.J. Miller. It was leased in 1922 by the Indiana Theater Company.

There are not any railroad cars traveling the rails near Railroad Avenue. Most of the coal delivered to the three large coal-fired electric power plants in Indiana County is brought in by truck. These rails are therefore obsolete and, in fact, have disappeared. In their place, the Rails to Trails project between Indiana and Homer City, the Hoodlebug Trail, has been constructed. This old railroad bed now serves as a walking and biking trail.

Cliffside Park was developed in 1922 by Antonio Bianco. It was located along Two Lick Creek, where a two-story building contained a summer residence, bathhouses, lunchroom, and lockers. Access was by streetcar or highway to a cliff, then by 101 wooden steps to the park. Water for boating and swimming was impounded by a log dam. Above on the cliff was a 40- by 100-foot dance hall. The park closed c. 1937.

FIRE STATION, HOMER CITY, PA.

After a disastrous fire in 1918, concerned citizens got together to establish the Homer City Volunteer Fire Department. Harry Flickinger served as the first fire chief, with Samuel Sickenberger as the first president. A lot was purchased in 1928 on West Church Street, where this fire station was erected. By 1954 the department was averaging 18 calls per year.

Old M. E. Church, Homer City, Pa. Built 1840

After a group of Methodists decided to settle in this area, they held their meeting in a private home and then in a schoolhouse. They built this log church *c.* 1837, which was formally dedicated in 1840. Armour Phillips donated the land for this church, the first one constructed in Homer City. This log building served the congregation until 1855.

Douglass Studio of Indiana took this photograph of the recently completed high school (below) in Homer City. High-school enrollment had reached 200 by 1927, with six faculty members. Because more room was needed, a $55,000 bond issue was initiated, and this new school was built in 1927. The new school contained eight classrooms and a combined auditorium-gymnasium. The old high school (right) later became an elementary school.

Public School Building, Homer City, Pa.

NEW HIGH SCHOOL HOMER CITY, PA.

SWIMMING POOL IN MEMORIAL PARK, HOMER CITY, PA.

On October 11, 1945, some Homer City citizens met to propose a community project that would be a "living memorial" for their veterans. This meeting led to the formation of the Community Memorial Association of Homer City. After construction of the football and baseball fields, ground was broken in 1948 for this 40- by 100-foot swimming pool, which was opened in 1949 and cost $30,000.

MAIN STREET NORTH, HOMER CITY, PA.

The bridge over Yellow Creek in Homer City was built in 1910. This photograph of Main Street was taken before the street was paved with brick in 1916. The street traced the path of an early road that allowed easy access to a fording spot on Yellow Creek. Notice that the trolley tracks, which were laid in 1907, followed Main Street. The 1910 population was 985. The town population had grown to 2,372 in 1954. As of the 2000 census, it stood at 1,844.

The Prairie State Incubator Factory was destroyed by fire on August 10, 1911. Emerging from this great fire was the "largest, finest and best equipped incubator factory in the world." The main building was 487 feet long and 272 feet wide, with two 60-foot wings that covered seven and a half acres. A concrete reservoir was built to contain 260,000 gallons of water for the fire hydrants and a sprinkler system inside the buildings.

The Prairie State Incubator Factory was founded in 1887 by James L. Nix and A.F. Cooper and named for Nix's home in southern Illinois. Two previous buildings were destroyed by fires in 1892 and 1911. The incubators were developed for raising chicks from eggs. By 1913, it was said to be the largest in the world. It ceased its operations in 1937.

View Homer City and Syntron Co.
Homer City, Pa.

This 1940s view of Homer City features the Syntron Company premises, former site of the Prairie State Incubator Factory. The Iler Electric Company took over the factory in 1930, and the Homer Electric and Manufacturing Company bought it in 1937. In May 1937 Syntron bought half of the factory, with the Indiana Chamber of Commerce raising $7,000 to help defray costs.

North Main Street, Homer City, Pa.

By April 1908, the tracks of the Indiana Street Railway reached Homer City, giving the residents of Yankeetown, Homer City, and Lucerne access to the trolleys. Later in 1908, tracks were extended from Rugh to Graceton and Coral, and to Josephine, Black Lick, and Blairsville by 1909. Pictured here is the intersection of old Route 119 and Greenville Road in Yankeetown.

View Lucerne Mines, R. & P. Coal Co. Homer City, Pa.

The town of Lucerne (Lucerne Mines) grew quickly. By 1928 it had 195 double houses, 50 single houses, a company store (Mahoning Supply Company), a doctor's office, and a baseball field, among other amenities. In 1917 some 1,500 miners supplied coal for the war effort, and by 1920 the Lucerne power plant (whose smokestack is seen here at the top right) supplied power for all mines of the Rochester and Pittsburgh Coal and Iron Company in Indiana County.

Mahoning Supply Company's Store, Lucern, Pa.

Many of the company towns had company stores, and Lucerne was no exception. The company store at Lucerne was the Mahoning Supply Company. It supplied food, clothing, furniture, tools, mining supplies, and other items to the miners, who could make purchases on credit. The Mahoning Supply Store burned on January 4, 1967, and Lucerne No. 3 mine closed in 1967.

By March 1907 a new mine had been opened by the Rochester and Pittsburgh Coal and Iron Company in a new town that the company chose to name Lucerne, located adjacent to Homer City. The *Indiana Evening Gazette* noted in September 1908 that the company ordered $6,000 worth of machinery from the Punxsutawney Foundry and Machine Company for a proposed power plant, which was completed in 1910.

Steam Shovel at Work on B. R. & P. R. R., Homer City, Pa.

The Rochester and Pittsburgh Railroad was organized on January 17, 1881. By 1883 it had track laid to Punxsutawney, Pennsylvania. By 1885 it was in financial trouble and went into receivership. Adrian Iselin, a New York City investment banker, bought the railroad, which owned all the stock of the Rochester and Pittsburgh Coal and Iron Company. On March 12, 1887, Iselin transferred the assets of his newly acquired railroad into a new company that he named the Buffalo, Rochester and Pittsburgh Railway Company.

Shaft, Lucerne, Pa., near Homer City, Pa.

The Buffalo, Rochester and Pittsburgh Coal and Iron Company moved into the Lucerne area and opened its first mine in 1906. Lucerne was named for Lucerne, Switzerland, homeland of its principal stockholder, Adrian Iselin. There were 1,500 men employed there in 1916, and it was noted that its "central power house is the largest, most complete and modern plant in the country." This power plant closed in August 1964.

B. R. & P. C. & I. Co's Tipple, Lucerne, Pa., near Homer City, Pa.

A published account in 1916 listed that these structures had been erected at Lucerne: powerhouse, blacksmith workshop, carpenter and machine shops, supply house, and hosting engine house. Mine cars, each holding two tons of coal, were hauled by electric locomotives. There were 45 miles of mine railway, and the capacity of the mine was 6,000 tons daily.

The first school in Armagh was held in a log cabin built in 1799 near the Presbyterian church. Other schools followed, and in 1923 the school board decided to build this brick high school at the west end of Armagh. The school's principal for many years was Ernest Kinsey. This high school was used until 1954, when a new school was erected. The Armagh schools are now part of the United School District.

Armagh, which means "field on a hill," was settled in 1792 by immigrants from Armagh, Ireland. It became a borough in 1834 and is the oldest of all existing towns in the county. Pictured c. 1928 is the oldest building in Armagh, the Campton Hotel (built in 1858). After John Christopher Campbell bought the building in 1912, it was acquired by his grandson Zan Johnston and his wife, Kathryn Johnston.

The Buena Vista Iron Furnace was built in 1847 by brothers Henry and Elias McClelland, along with Stephen Johnson. It is located in Brush Valley Township along Black Lick Creek and is the only furnace in the county still standing, although part of it has collapsed. The furnace is 30 feet high, and its base is a square 32 by 32 feet, tapering to a square 22 by 22 feet. Iron production ended c. 1854.

The little village of Mechanicsburg (Brush Valley) was laid out in 1833 by John Taylor on behalf of Robert McCormick. This photograph, taken by L.H. Lowman of Cherry Tree and later of Clymer, shows how popular the "select school" or "summer normal school" was at Mechanicsburg in 1907. The primary purpose of the summer normal school was to prepare teachers for the county superintendents' examination.

73

Clyde, Pennsylvania, formerly known as Little Washington, is located about two miles west of Armagh on Route 22 in West Wheatfield Township. It was formerly a station on the Philadelphia and Pittsburgh Turnpike. This *c.* 1910 scene shows Route 22, also known as the William Penn Highway, before it was paved.

Bethel U. P. Church and Cemetery. First burial about 1818, A. D.

The Bethel Associate Reformed (United Presbyterian) congregation was organized *c.* 1808. The congregation erected its first church south of Clyde in West Wheatfield Township in 1818. This *c.* 1912 view shows the cemetery alongside the church. There were about 26 Presbyterian churches in Indiana County by 1844. Fourteen were regular Presbyterian; six were Seceder; five were Associate Reform; and one was Covenanter.

Four
The Clymer Area

Clearfield Bituminous Coal Co.'s Office, Clymer, Pa.

The Clearfield Bituminous Coal Corporation's (CBC) office at Clymer was built in 1906 at the corner of Sixth and Sherman Streets. Its company store, the Clearfield Supply Company, was built alongside. Both of the CBC mines—the Clymer No. 1 mine, which opened in 1905, and the Clymer No. 2 mine, which opened in 1936—were served by this office. When the mines shut down in the 1950s, the building became St. Anthony's Convent. It is now the site of a dental practice.

Arthur Godfrey, king of radio and television for over three decades, once tried his hand at coal mining in Clymer. In 1919 he took a job as a typist for the U.S. Army at Camp Merritt in New Jersey. He struck up a friendship with a Clymer resident, Vincent Stahl, who convinced Godfrey to come to Clymer with him. They both got jobs mining coal for the Clearfield Bituminous Coal Corporation. Godfrey quit after only four months on the job.

Although the Clearfield Bituminous Coal Corporation founded Clymer, it was not a true company-owned town. The company set up the Dixon Run Land Company to handle dispossession of lots on October 11 and 12, 1905. At an average price of $306 per lot, 103 lots were sold. When this postcard was mailed on July 30, 1907, there were 40 stores, 2 hotels, 2 liveries, 2 blacksmiths, 2 drugstores, a four-room school, and 1,500 citizens.

John S. Fisher, the 30th governor of Pennsylvania, was born in South Mahoning Township, Indiana County, on May 25, 1857. He became a legal counselor for the New York Central Railroad *c.* 1900. Fisher was active in the formation of Clymer in 1905 through his role as president of the Dixon Run Land Company, which drew up plans for the town and sold lots. He was also president of the Clymer Brick and Fire Clay Company, incorporated in 1907.

Union Depot, Clymer, Pa.

The Cherry Tree and Dixonville Railroad arrived in Clymer in November 1905. It was unique in that it was jointly owned by the Pennsylvania Railroad and the New York Central Railroad. Union Depot, pictured here, was built in 1906, and passenger service started on April 1, 1907. The New York Central ended passenger service in February 1933, and the Pennsylvania terminated passenger service on October 4, 1947.

By 1910 Clymer's population was 1,753, making it the third largest town in Indiana County. By 1940 its population had grown to 3,082, the largest mining town in Indiana County. John Dillon and his family were the first settlers to arrive on September 25, 1905. They opened a boardinghouse on Hancock Street to house the engineers and officers of the Clearfield Bituminous Coal Corporation, which was overseeing the construction of Clymer. The first store built was the Clearfield Supply Company Store on Adams Street. The post office opened on February 8, 1906. In the same year, the elementary school and the Clymer Hardware Store opened. In 1907 Neeley Hotel, Clymer House, and Strong's Store opened their doors. The Opera House and the Presbyterian church opened in 1908.

This view shows the main street of Clymer, Franklin Street, looking west in 1907. Wooden sidewalks were the rule, with mud everywhere when it rained. Franklin Street was not paved until 1922; Sixth Street followed shortly thereafter. Parking meters and a single traffic light were not installed until 1946. Strong's General Merchandise Store is the large store on the left. On the right, among others, are Lariff's Shoe Store and the Clymer Hardware Store.

This view of Franklin Street actually looks east. The Houck Building (right) housed Clymer's post office at this time. The post office was previously housed across the street in the rear of the Clymer Hardware Store. Clymer became a borough on February 29, 1908; it covered an area of 304.78 acres. The borough outgrew its limits and on December 9, 1914, enlarged its limits considerably.

Civil War Veterans' Float, Old Home Week, July, 1915, Clymer, Pa.

To celebrate the 10th anniversary of the founding of Clymer, an old home week celebration was held in July 1915. Its official title was the Clymer Homecoming and Fireman's Celebration, which began on July 20, 1915, with a street carnival. July 21 was Merchants and Farmers Day, culminating with the laying of the cornerstone of the municipal building. July 22 was Fireman's Day, featuring contests between fire companies. July 23 was Miners Day, during which W.B. Wilson, U.S. secretary of labor, gave an address and a parade was held. The celebration ended on July 24 with a final parade, a band concert, and a baseball game. Pictured here are many of the floats entered in the parade.

By 1907 Clymer had two hotels: the Neeley Hotel and the Clymer House (pictured here), which was located on South Sixth Street. With a population of 1,500 by 1908, Clymer needed both of them. They provided rooms for businessmen, travelers, and officials of not only the local coal companies but also of the newly formed Clymer Brick and Fire Clay Company, whose president was the Honorable John S. Fisher, general counsel of the New York Central Railroad.

Shown c. 1955 is the intersection of Franklin and Sixth Streets, the business district of Clymer and the location of the only traffic light. On the left are the hardware store, Lariff's, the pool room, the liquor store, Zanot's, Scerbo's, Cohen's, Bracken's, Graziano's, Vargo's, the Perry apartments, Tate's, and Clymer Gas and Oil. On the right appear Neal's, the bank, Levinson's, Sugar Bowl, Strong's, C & S, Abraham's, A & P, and the Clymer Legion.

81

Birds Eye View, Clymer, Pa.

This bird's-eye view of Clymer looks north from the hill above Walcott Street *c.* 1950. On the right, the elementary school, the high school, and the middle school (with the Methodist church on the left of the high school) are visible. In the middle of the picture is St. Michael's Orthodox Greek Catholic Church. The top end of Sixth Street, running south to north, is visible at the bottom.

National Bank Building, Clymer, Pa.

The Clymer National Bank, charter No. 9,898, opened for business on January 16, 1911. It was housed in this two-story brick building, built in 1911 at the corner of Franklin and Sixth Streets. The bank was located on the first floor, along with a mercantile store. The second floor housed offices, including that of dentist H.J. Dunegan. The basement housed a plumbing and tinning business along with a barbershop.

Municipal Building, Clymer, Pa.

The municipal building in Clymer was erected in 1915. The bottom floor housed the Clymer Volunteer Fire Company, and the second floor housed the borough offices. In 1948 the brick extension was added, and the truck on the right was purchased. The truck on the left was purchased in 1953. The fire company relocated to Sherman Street and erected its new buildings there. A new municipal building was erected in 1989.

Public School Building, Clymer, Pa.

The first school erected in Clymer was a four-room frame structure built in 1906 on Hancock Street. In 1909 it was enlarged by adding four more rooms, and the whole building was cased in brick, as seen here. This school was actually built by Cherryhill Township and was known as School No. 3. When Clymer became a borough in 1908, the borough bought it from the township.

Public High School, Clymer, Pa.

In 1912 a two-year high-school curriculum was introduced, and in 1913 Clymer had its first graduate, Gladstone Christie. In 1915 a three-year high-school curriculum was adopted. The four-room buff brick high-school building above was erected in 1916 on Hancock Street, across the street from the primary building. In 1923 a new eight-room buff brick building was built on Morris Street. It housed high-school classes until 1926, when an eight-room extension to the original high-school building on Hancock Street was added. Pictured below is the original high school with the eight-room extension. This school served Clymer until the new Penns Manor High School opened in 1961. On July 8, 1952, Clymer became part of the new Penns Manor Area School District formed by the mergers of schools in Clymer Borough and in Cherryhill and Pine Townships. After the merger, this high-school building served as an elementary school for the district.

High School, Clymer, Pa.

The Goaziou Studio in Clymer published this fine old photograph of Irwin Smith's barbershop, on North Sixth Street where B & B Screen Printing is now located. During the 1940s and 1950s, Dr. Capizzi had his office in this building. A Civil War veterans memorial stands in front of the barbershop in honor of the "Clymer Soldier Boys."

Standing in front of their tool shed outside Clymer c. 1910 are members of a repair crew from the Cherry Tree and Dixonville Railroad. Rails were laid into Clymer in November 1905, and these men were charged with keeping the rails in good order. This railroad was co-owned by the Pennsylvania and New York Central Railroads. The Clymer and Barr Slope mines shipped all their coal over these rails. Notice the self-powered rail car.

Every town had its musicians, and Clymer was no different. A cornet band was formed in 1914, and later this Clymer Concert Band was organized under the direction of Prof. Salvatore Cappella. This c. 1939 photograph was taken on the steps of the Clymer Primary School Building. Edward "Buzz" Cupples (fifth row, second from the left) still resides in Clymer.

The Loyal Order of the Moose No. 670 was founded in Clymer in 1911. In 1917, the organization erected its new building at Sixth and Adams Streets, which is still used by the group. It sponsored the Clymer Girls Drum and Bugle Brigadiers, with Prof. Salvatore Capella as director, as shown here in a 1939 photograph.

These two scenes of Franklin Street portray Clymer, looking east. The scene above, dating from *c.* 1907, shows the intersection of Franklin and Sixth Streets. The Clymer Hardware Store had been recently constructed (left). Behind the hardware were the post office and the express office run by John Lixfield. There were no fire hydrants and no fire company yet; people got their water from springs and wells. Pictured below is the Neeley Hotel (at Franklin and Fifth Streets), which later housed the American Legion Post No. 222. Across the street from the hotel, where the two men are standing, was the Opera House, Clymer's entertainment center.

CLYMER DRILL
TEAM 1933

CAPTAIN
STEVE RENSKOSKI

PUMPER
CECIL CHRISTIE

TEAM

WESTON DAVIS
CHESTER LONG
BEACY BIANCO
ED. VASBINDER
HAROLD DAVIS
HAROLD RAGER
JOE POTOCEK

RESERVES

D. W. LYLE
CLARENCE TREESE

The Opera House in Clymer opened on Christmas Day 1908. On December 18, 1909, it was destroyed by one of the largest fires to occur in Clymer. Although there were fire hydrants, there was no fire hose, and a bucket brigade had to be used until help arrived from Indiana. As a result of the public uproar over the fire, the Clymer Volunteer Fire Company was formed. Here the 1933 drill team is shown alongside its 1923 Seagrave truck.

This is the tipple of the Clymer No. 1 mine. The mine started producing coal in 1905, and the No. 2 mine was opened in 1936. They were captive mines, producing coal for the steam locomotives of their parent company, the New York Central Railroad. By 1955 they had closed. The greatest mining disaster in Indiana County occurred at this mine on August 26, 1926, when 44 miners died as a result of an explosion.

On a visit to the McKean Mine near Clymer, the Honorable John S. Fisher noticed a grayish material under the coal seam. He had some of it analyzed, and it turned out to be a high grade of clay. He then organized the Clymer Brick and Fire Clay Company, which was incorporated on April 9, 1907, with Fisher as president. The company bought 200 acres of land adjacent to the borough on Route 403 South. It invested $150,000 in the plant seen here, and by 1910 it was the largest brickyard in Pennsylvania. The plant produced paving and building brick and radial chimney brick. Quite a few homes in Clymer were constructed using this brick. Hiram Swank of Johnstown, Pennsylvania, purchased the plant in 1917 and renamed it Hiram Swank's Refractories, Clymer Plant. Brick production ceased, and Swank's company made clay nozzles of different types for the steel industry. It closed in 1977.

The Clymer Brick and Fire Clay Company Mine was located on the hill overlooking the plant below. A coal seam of 3½ feet was layered over a 17-inch seam of clay. The coal and clay were dug separately, loaded onto cars, and pulled out to the main headings by mules. Electric motors then pulled the cars outside the mine. Coal was used to fire the kilns that baked the clay.

Commodore was named for Commodore Vanderbilt, founder of the New York Central Railroad. The Clearfield Bituminous Coal Corporation, a subsidiary of the railroad, opened two mines in late 1919 at Commodore. These mines in the Purchase Line field mined the upper Freeport seam of coal. This tipple had a capacity of 1,500 tons of coal per day. In the background were the first post office and Sweitzer's store.

The company houses in Commodore were built using solid cement blocks. These blocks were made on a site where the athletic field was once located along old Route 80. John Klinglesmith, an Indiana contractor, patented the blocks, which the Clearfield Bituminous Coal Corporation (CBC) decided to use for workers' houses. Shown above is a crew pouring cement into wooden forms to make these blocks. Below are partially completed houses c. 1920. The CBC mill at Clymer furnished lumber for the frames of the houses. Tenants said they were "cool in summer and warm in winter." Each house had electricity and running water, with rent being $14 per month. In 1924 mechanical toilets were put on the back porches of these houses and sewage made to flow into a sanitary sewer system. A coal town with a sanitary sewer system at that time was a rarity; only two other towns in the state had similar facilities. This is one of the reasons CBC presented Commodore as a "model" coal town.

George Jaquish, who had opened the mines at Clymer, supervised the opening of the Commodore mines. Paul Gill, engineer, laid out the town. Streets were named after the Vanderbilt family, F.E. Herriman (president of the Clearfield Bituminous Coal Corporation), H.B. Douglas (vice president), and H.J. Hinterleitner (general superintendent). By 1920 this shop, motor barn, tipple, and blacksmith shop were in operation. On the right are company houses at the upper end of Vanderbilt Street.

After opening its first mine in Indiana County at Rossiter in 1900, the Clearfield Bituminous Coal Corporation came to Clymer and Barr Slope in 1905 to open more mines. Barr Slope near Dixonville was named for W.N. Barr, a local landowner. This photograph, dated May 19, 1909, shows damage after the drum house, rope, and tracks were destroyed by a large dynamite blast. Foul play was suspected, which led to a state constabulary investigation.

Dixon Run got its name from the Dixon brothers, who pastured their cattle near it. Dixonville, named after Dixon Run, was first settled in 1801 by Welsh pioneers. Sometime near 1860, the village began to be developed. The post office opened on July 14, 1868, with George Row Jr. as postmaster. Lumbering was an important winter activity, but agriculture was the main industry until the mines started opening up in 1905. There were 35 mines in the Dixonville area from 1905 to 1960. Over the years it has had at least 58 grocery stores, 5 appliance and furniture stores, 2 undertakers, 2 hardware stores, 2 variety stores, 2 gas stations, and a hospital.

The early name of Tanoma in Rayne Township was Bum Bee. Clarence D. Stephenson wrote, "Two men at a blacksmith shop apparently were wrestling in a field and rolled onto a bumble bee's nest, hence Bum Bee." Samuel Kuhns (Koontz) coined the name "Tanoma" by using the first letters of his children's names: Tillie, Alice, Norman, Matilda, and Alice. The post office opened on March 5, 1888, and closed on July 31, 1911.

Lovejoy, in Green Township, was a coal town built c. 1903 and named after a mine foreman, Frank Lovejoy. A post office opened on February 24, 1904, with Amariah Buterbaugh serving as postmaster, but it closed on November 13, 1919. The Greenwich Coal Company opened its Mine No. 4 here. By March 1911 there were reports that the site was being abandoned because of water in the mine. The rails were in the process of being removed, and only four company houses were occupied.

Five
The Marion Center Area

B., R. & P. STATION—MARION CENTER, PA.

In 1885 a New York banker, Adrian Iselin, purchased the Buffalo, Rochester and Pittsburgh Railway. Business boomed in Jefferson County, and the company decided to enter Indiana County. The first rails were laid near Juneau in October 1902. Trains were running through Marion Center by April 1903. The first passenger train stopped at this station on May 3, 1904; the last one, the Hoodlbug, left on June 10, 1950.

John B. McCormick, inventor of the famous McCormick Holyoke Turbine Wheel, was born on November 4, 1834, near Altoona but moved with his family to Smicksburg when he was three years old. He left for Holyoke, Massachusetts, in 1876 to perfect his turbine. After achieving success he returned to Marion Center and rebuilt this "box" of a house into the one shown in this c. 1885 view on Manor Street, doing most of the work himself.

The store of H.P. Wetzel was located at Main and Craig Streets in Marion Center. By 1887 Wetzel had built a 20- by 40-foot storeroom where he sold woolen goods and other merchandise. He finally added a 40-foot addition, making this building 20 by 80 feet in area and three stories high. He was succeeded by Frank Wetzel, who operated a grocery store on the site until c. 1940.

The Marion Center Cornet Band was organized c. 1876 with 14 members. Prof. J.M. Blose of Marchand was hired as the instructor of the band in 1882, and band members met in a room over McGinty's harness shop. Pictured in 1917 are Bernard Fulmer, Cecil Craig, John Walker, Lydia Walker, Carolyn Moore, Byron Mulberger, and Arren Washington. Holding the Marion Center pennant in the back is S.J. McManus.

Alexander Adams built the second hotel in Marion Center on Main Street. It was torn down in 1879, and Adam Bates erected his Hotel Marion on the same site. It was a three-story hotel with 15 rooms. Levi Lowmaster served as proprietor. It was run by I.R. Kinter in 1882; a Mr. Morrow in 1885, and H.M. Fleck in 1889. Fleck operated it until he died. J.F. Wadding and Miles McIntyre were the lessees at the time it burned in the 1920s.

Prior to 1860, Presbyterians in the Marion Center area worshiped at the Gilgal Presbyterian Church north of town. Rev. John Carcethers was installed as the new pastor of the Marion Center congregation on July 10, 1861. This 48- by 65-foot two-story building was completed in 1871 at a cost of $6,000. On the first floor were the lecture room, pastor's study, and furnace room. The upper story housed the auditorium.

The first issue of the *Marion Independent* was published on December 24, 1881, by J.C. Rairigh, editor. Charles R. Griffith, a great-grandson of John Park (the founder of Marion Center), was listed as its owner on March 11, 1882. He became editor of the paper on April 15, 1882, at age 19. The paper and job presses were run by steam. This is what the plant and his residence looked like *c.* 1900. He died on September 26, 1935.

This postcard, dated September 14, 1909, depicts the residence and dental parlor of Dr. L.N. Park and pharmacy of William Griffith on Main Street. Dr. Park purchased the business in June 1873. He was the nephew of Linton Park, the youngest son of John Park. Linton Park went on to invent the Venetian window blind and became one of the most famous primitive painters in the United States.

Marion Center had a very popular summer normal school, as is illustrated by this photograph of the 1914 class. Joseph Weaver was one of the instructors at that time. The length of the summer course of instruction was usually no longer than 12 weeks. Passing the county superintendent's examination qualified one to teach in the common schools.

This 1908 view of Marion Center features Main Street, looking west from Manor Street. The large brownstone brick building on the right is the Marion Center National Bank, which opened on August 21, 1905. It is the largest independent bank in the area, with branches in Big Run, Clymer, Dayton, Punxsutawney, and Willow Springs. Alongside is the Mahoning House, and across the street is the S.H. Jones store.

The Mahoning House was located at Main and Manor Streets. It sat on the site of the former large general store erected during the 1870s by McLaughlin, Kinter and Company. It was converted to a hotel by Horatio Simons, and on June 1, 1904, it became the Mahoning House. It was torn down in the late 1930s to make way for Harry Black's service station.

The first school in Marion (Marion Center) was a crude log building on North Manor Street. William Work was the first teacher. It burned in 1834, and in 1848 a second school was built. A third public school building was erected c. 1860, before Marion became a borough in June 1869. The public school pictured here was built in 1901 on North Manor Street and served as the high school from 1916 to 1929.

Georgeville is the oldest village in East Mahoning Township. Lansing Bills, a blacksmith, built the first house here. A home and a tan yard were erected by George Hoover in 1824. When his brother-in-law Andrew Comptar arrived c. 1830, they decided to lay out the village of Georgeville and name it after Hoover. The post office was named Georgeville on March 13, 1874, and was in operation until June 30, 1934.

Although Plumville was incorporated as a borough on December 9, 1909, its beginnings date back to the early 1800s. John McEwen was one of the early settlers and named the town after the abundance of plum trees he found there. He opened the first merchandise store and later served two terms in the state assembly. His son Christopher was the first doctor in the area. The Plumville Hotel was run by Henry Fleck and his wife.

One of the oldest businesses established in Plumville was J.W. Douds and Company, which offered country produce and general merchandise. Alex Thompson had a tannery here. Dennis Andrews and William Bowser were early dentists. Elisha Green ran a drugstore, and the Stear family operated the first gristmill. The First National Bank of Plumville opened on December 26, 1905, with $30,000 in capital stock (300 shares).

Smicksburg is located on Route 954 in West Mahoning Township. It was laid out in May 1827 by Rev. J. George Schmick on 12 acres of land he bought from Charles Coleman. On October 1, 1830, John Kerr, the local blacksmith, became postmaster. Smicksburg became a borough on June 28, 1854. In the 1940s half the town was swallowed up by water from the Mahoning Creek Dam project, including this Lutheran Church property.

Richmond, or Rochester, Mills is in Canoe and Grant Townships. David Simpson built the first house and mill here. The area was known as Simpson's Mill until 1862, when it was named Richmond after the capital of the Confederate states. John Rochester built a sawmill and flour mill here *c.* 1836, and then it became Rochester Mills. The post office opened on July 25, 1871; John Rochester was the postmaster. The community was a stronghold of the Greenback-Labor movement.

This is a 1942 view of the Shelocta Inn, located on Route 422 nine miles west of Indiana. Shelocta was originally known as Sharpsburg when Thomas and Joseph Sharp erected their gristmill there in 1824. Its name changed in 1836, when a newcomer, Abner Kelly, mapped the area bordering Crooked Creek into a hamlet he chose to call Shelocta.

The tiny village of Five Points, located in the western part of Indiana County near Plum Creek, has not changed much since 1855, when 25 citizens lived there. Sam McGary built the first store in 1858, and Solomon Hankinson was the first blacksmith. Smith and Boyer had an undertaking business here in 1868. The old Five Points Lutheran Church was built in 1880, and in front of this church stood the one-room Marlin School.

Ernest, formerly called McKee's Mills, was the first coal town in Indiana County to be developed by the Rochester and Pittsburgh Coal and Iron Company. In May 1903, the first coal was shipped out over the new Buffalo, Rochester and Pittsburgh Railroad. By September, a steel tipple was nearly finished, coke ovens were being built, and by December the town was nearing completion.

In 1904, a power plant was completed that provided power for mine locomotives and powered a chain system to hoist cars up an incline into the tipple. Shortly thereafter, a coal washing plant and crusher (pictured here) and 278 coke ovens were "well under way." The number of men working inside the mines in 1906 was 1,026. The Rochester and Pittsburgh Coal and Iron Company sold the town of Ernest to Kovalchick Real Estate on January 1, 1947.

Stannardsville, Kellysburg, and then Home were the names of earlier post offices in this small village in Rayne Township. Home supposedly got its name from the fact that the first post office in 1834 was in Hugh Cannon's "home." This *c.* 1910 view shows the Big Road, later called the Old Mahoning Road and now Route 119, before it was paved. On the right are the tracks of the Buffalo, Rochester and Pittsburgh Railroad.

Newville (Creekside), in Washington Township, was laid out in 1854 by David Peelor for John Weamer, and a July 4, 1855 celebration was held at a stand along the banks of Crooked Creek. Creekside was named for its location along Crooked Creek. Creekside Post Office opened on July 12, 1870; William St. Clair was the postmaster. By 1880 Creekside had a population of 50.

Six
THE GLEN CAMPBELL AREA

This *c.* 1908 view of Glen Campbell shows a portion of Glenwood Avenue (Main Street). On the right is the Union Church. A Presbyterian congregation was formed in 1894 and held services in this church. Andrew Carnegie donated an organ to be used in the church. The building was renovated in 1954. In 1967 the Presbyterian congregation dissolved and merged with the United Methodists. The school is to the left of the church.

Most towns had a hotel or two, but Glen Campbell had at least four. In 1909 Grant Snyder opened the Commercial Hotel, which burned on May 15, 1914. By 1916 Snyder was running the Hotel Snyder. He and John Fitzpatrick took over the Capital Hotel, said to be a "first class establishment noted for its good meals and excellent service." In January 1928, the Capital burned. Schrader's Hotel suffered the same fate.

The Commercial Hotel opened in 1909, with Grant Snyder as proprietor. On May 15, 1914, a fire destroyed an entire block of Glen Campbell, including a bank, the Odd Fellows Hall, several stores, and this hotel. The hotel was not rebuilt. Instead, another hotel with 50 rooms, the Capital, took its place.

The Independent Order of Odd Fellows was originally an English organization. Its mission was to "visit the sick, relieve the distressed, bury the dead and educate the orphans." A fire on May 15, 1914, destroyed the bank, several stores, other buildings, and the original Odd Fellows Hall. The group erected this two-story, 45- by 90-foot buff brick building in 1915. The first floor housed a shoe store and a general store, with the social hall on the second floor.

By 1894 Glen Campbell was booming. The Glenwood Coal Company had 265 employees; the Reakirtsdale Coal Company, 75; and the Urey Ridge Coal Company, 100. Two large sawmills employed 40 men. The community had the Union Church, one schoolhouse, six general stores, a clothing store, a hardware store, three butcher shops, three drugstores, a flour and feed store, four hotels, a newspaper, a doctor, and liveries. Glen Campbell's population was 1,628 in 1900.

109

This postcard dated 1907 features the post office in Glen Campbell. The post office opened on November 5, 1889, with Cornelius Campbell as postmaster. The Glenwood Coal Company shipped its first carload of coal on October 21, 1889, over the Clearfield and Jefferson Railroad to McGee's Mills about 12 miles away. This new railroad was the first to be built in Indiana County since the Pennsylvania Railroad came to Indiana in 1856.

Glen Campbell, founded in 1889, was Indiana County's first mining town, developed by the Glenwood Coal Company and Cornelius Campbell, for whom the town was named. It was reached by the Cush Creek extension of the Clearfield and Jefferson Railroad. This view of upper Main Street is dated 1907. Glen Campbell was incorporated as a borough on September 27, 1894. An extension of Glen Campbell was Reakirtsdale.

The Baptist church in the middle of this photograph was originally built for members of another Christian denomination, but its members were unable to pay the mortgage. A group of Glen Campbell families took over the mortgage and formed the First Baptist Church on August 24, 1902. Rev. Allan Campbell of Indiana, a direct descendant of Cornelius Campbell, has been the pastor for the past 30 years.

This two-story frame building, pictured *c.* 1911, housed the public school at Glen Campbell. The date of the fire that destroyed it is unknown. A large fire on November 22, 1924, consumed over one block of Glen Campbell's Main Street. Destroyed were Cressley's Nickelodeon, Conner's Drug Store, Hamity's Ice Cream Parlor, and a barbershop. To keep the fire from spreading farther, the 108-foot-long, three-story Burnside Supply Store was dynamited. Total damage amounted to $75,000.

This photograph of Main Street (Glenwood Avenue), Glen Campbell, Banks Township, is presumed to have been taken on June 12, 1911. At the extreme left is the First National Bank of Glen Campbell, which opened for business on July 25, 1899. A few doors down the street is the John T. Kane Department Store, which opened in 1895. The store delivered merchandise by horse and buggy in the summer and by sleigh in the winter. It closed in the early 1950s.

Arcadia "signifies contentment . . . for its pastoral location," read a 1900 advertisement. It was described as a "model mining town" at that time. The Pennsylvania Coal and Coke Company was the founder. Clark Avenue was apparently named for G.O. Clark. By 1913 there were two coal company stores, meat markets, a livery stable, United Mine Workers of America hall, hardware store, and several general stores. At that time, the Pennsylvania Coal and Coke Company was constructing a power plant and office building.

Arcadia Churches, Arcadia, Pa. Taken From Cush Creek Hill.

One of these churches was Presbyterian, organized soon after the town was founded, with Rev. Charles B. Wingerd as pastor. The others are not identified. One was almost certainly Roman Catholic. The one on the right appears to have a Russian or Greek Orthodox spire. Electricity (note the utility poles) was provided by the Giant Electric Light, Heat and Power Company of Glen Campbell. The post office opened on March 15, 1902. Joseph H. Ake was the first postmaster.

No. 11 Mine, Arcadia, Pa.

By 1914 there were five Arcadia mines (Nos. 40, 41, 42, 43, and 44), producing 259,329 tons of coal. The Pennsylvania Coal and Coke Company sold the mines to the Clearfield Bituminous Coal Corporation in 1911, which may account for the change in numbering. Another company, the Ellsworth Dunham Coal Company, had two mines in Arcadia in 1914.

After its founding in 1900, Arcadia, located in Montgomery Township along the south branch of the Cush Creek, became one of the larger coal towns in Indiana County. By 1913 it had a population of 1,200 and boasted three hotels. One of them was the large Arcadia House, pictured above. By 1917 America was involved in World War I, and all men between the ages of 21 and 30 had to register for military service. From this area 6,873 did so, on June 5, 1917. By April 5, 1918, 252 men had left for war. The largest group of 300 men left on May 28, 1918. The Indiana Military Band, the Glen Campbell Band, and the Arcadia Cornet Band (below) played at the station as the men were leaving.

The postcard view above (published by the Arcadia Pharmacy) was taken from the schoolhouse c. 1900–1905. To the right is Clark Avenue. The early principals of Arcadia's schools were James Smith, E.E. Irwin, R.L. Gartley, John Camp, John Rankin, W.C. McFarland, R.O. Lytle, Clifford McFarland, Professor Parks, John E. Davis, Ernest McKenzie, and Professor Houston. After leaving the Arcadia School, Davis was the supervising principal of the Clymer Schools from 1925 to 1939. He became principal of the Keith School at Indiana State Teachers' College in 1939 and later served as president of the college.

WILLIAM PENN MONUMENT AND C. T. VOL. FIRE CO. CHERRY TREE, PA.

The William Penn Monument at Cherry Tree, marking "Canoe Place," was dedicated on November 17, 1894. This monument was erected on the spot where a large, black wild cherry tree stood, to which Native Americans tied their canoes. It also marks the corner of the proprietaries purchased from the Six Nations Tribes Indians at the treaty of Fort Stanwix in New York on November 5, 1768. This is also the point where the three counties, Indiana, Cambria and Clearfield, meet in Cherry Tree.

The First National Bank of Cherry Tree was chartered in October 1903 with charter No. 7,000. Its original capital was $25,000, but it was increased to $50,000 in 1904. By 1922 its resources were $1,962,285. It went into receivership on October 13, 1933. Later this bank building became home to the Cherry Tree office of the National Bank of the Commonwealth (First Commonwealth Bank), and it continues today as such.

Cherry Tree was settled in 1822 by John Bartlebaugh and Peter Gordon. Their cabin was located on what later became the public school grounds. In 1830 the first male child, Abner Bartlebaugh, was born in the community and a post office was opened. It was named Bardsville after Richard Bard, the postmaster. This post office was located near the New York Central yard office. In 1833 the name of the office became Newman's Mill, and in 1867 it became Grant. Finally, in 1907, it became Cherry Tree.

The first hotel in Cherry Tree was built by Samuel Smith in 1845. Richard Bard built a house on North Main Street, which housed his tavern. Absalom Harter's residence also served as a hotel for several years. Ed King opened up an inn, the Eagles Hotel, which L.M. Clark bought later. By 1870 the Weaver House was erected by Capt. D.J. Weaver. Later it was remodeled by Alex Henderson and operated by David Smith.

The first school directors meeting was held in Cherry Tree on July 23, 1855. The Odd Fellows Hall was the location of the first school, where E.D. Porter taught 62 students. A two-story frame school was built in 1867 and served as the school until 1911, when this four-room brick building was erected and a high school established. There were three grade-school teachers and two high-school teachers in 1922 who taught 191 pupils. The average cost of educating each student was $4.52 per month.

Cherry Tree is located at the junction of Cush Cushion Creek and the West Branch of the Susquehanna River; in fact, this is where the large wild cherry tree that gave the town its name stood. Because these streams are very shallow, floods are inevitable, and this flood scene shows the high-water marks of the March 13, 1907 flood. The white-pine industry took advantage of the flooding. A lot of water was needed to float 8,000-cubic-foot pine rafts down the Susquehanna.

"The Last Raft"
Going Down the Susquehanna River
near Indiana, Pa.

Cherry Tree was blessed in that it was near the great virgin white pine forest of Pennsylvania, and the Susquehanna River was able to handle the large rafts of white pine that originated here. The first raft was sent down the river in 1827 by Reeder King and Josiah Woodford. Lumbering of pine trees was the major industry in this area from 1840 to 1890. One pine log felled in 1882 scaled 2,116 board feet. The last ceremonial raft went down the Susquehanna River in 1938.

MAIN STREET CHERRY TREE, PA.

Cherry Tree became a borough on April 30, 1855. It required a special act of the Pennsylvania legislature to make it a borough, because it actually was in three counties: Cambria, Clearfield and Indiana. By 1922 it had two railroads (the Cherry Tree and Dixonville and the New York Central), a four-room brick school, a national bank, the Cherry Tree Iron Works, and McKeag's roller flour mill. It also had many stores, hotels, and an Odd Fellows building.

The first mine of the Clearfield Bituminous Coal Corporation, a subsidiary of the New York Central Railroad, was opened in a town the company named Rossiter in 1900. This town was named after E.W. Rossiter, who was the treasurer of the railroad and a large stockholder in the corporation. Pictured above is the powerhouse for its Canoe Ridge mines, which provided coal exclusively for the locomotives of their railroad. By 1901 the population was "almost 1,000," and in 1914 the number of employees working there was 700. There were two hotels in town: the Rossiter House, run by W.J. Daughtery, and the Brandon Hotel (below), run by M.S. Murphy. After 42 years of mining, the deep mine coal was exhausted and production ceased. The company's last strip-mined coal from Rossiter was shipped in 1946. In 1946 the Loree Footwear Corporation of New York set up a shoe factory in the old motor barn.

Seven
THE HEILWOOD AREA

Pictured here are the Possum Glory Coal and Coke Company No. 1 tipple and power plant at Heilwood. A small lumber village called Guthries Mills, *c.* 1888, was located near Heilwood, and this village was nicknamed "Possum Glory" because of the large numbers of possums in the area. The station here then became known as the Possum Glory Junction, from which the Possum Glory Coal and Coke Company got its name.

Heilwood, Penna.

In 1904 John Heil Weaver bought a piece of land from John Bowers and opened up three mines in Pine Township. The town that he set up matched his own middle name, "Heil," He sold his interests to the Penn-Mary Coal Company in 1906, and it in turn opened up five more mines. In the center of the photograph above is the Penn-Mary Company Store, the Heilwood Company, which handled general merchandise and where miners had credit accounts. In the lower part of the picture is the amusement center, a large two-story building that housed two bowling lanes, pool tables, a barbershop, and a kindergarten. Roller-skating and dancing areas were located on the second floor. Below is a closeup of the company store.

Store Building—The Heilwood Co., Heilwood, Pa.

THE HEILWOOD COMPANY.

When the Penn-Mary Coal Company purchased the John Heil Weaver and Company holdings in 1906, there were only three mines in operation, but by 1914 five more mines were opened. Pictured c. 1908 is the Incline Plane at the No. 4 mine. In 1914 the No. 1, 2, 3, and 7 mines produced 574,319 tons of coal and employed 712 people. The company general superintendent was H.J. Meehan, and the mine superintendent was Charles Severn.

Entering Heilwood on Route 403, traveling south, the old high school is on the left. Situated behind the school was a unique operation, the Heilwood Company Dairy. The Heilwood Company leased 400 acres from the Penn-Mary Company and ran a dairy that produced milk and meat for its company store. Next to the dairy were the high-school faculty dormitory, the Penn-Mary Hospital, and these four homes, which housed company officials.

One of the four houses located on Staff Street near the hospital, the house pictured above was the residence of John M. Thompson, manager of the Heilwood Coal Company. When the Heilwood post office opened on October 29, 1904, John M. Thompson was the postmaster. The fifth house on this street, the large white one with an impressive entryway, pictured below, was the residence of H.P. Dowler, general superintendent of the Penn-Mary Coal Company. The population of Heilwood reached 2,400 in 1914. After the mines closed *c.* 1926, the population declined. The hospital closed during the Great Depression, and the railroad station closed in 1941. Although other companies came in later and took over some of the mines in the area, the coal production from the mines never equaled the "glory days" of the early 1900s.

Although coal production was the main interest of the Penn-Mary Coal Company, the company built many amenities: schools, stores, homes, a hotel, an amusement hall, a company store, a dairy, two churches, and a hospital. This view shows the general office of the Penn-Mary Coal Company.

In 1905 Dr. R.F. McHenry started a hospital in a miner's shanty in Heilwood. In October 1901 the hospital moved into the facility shown here, the first building in Indiana County erected solely for hospital purposes. This modern Penn-Mary Hospital was built by the Penn-Mary Coal Company for $25,000. Miners were assessed 10¢ per month in 1905 and 40¢ per month by 1909 to cover healthcare for themselves and their families. Outsiders were charged $1 per day for ward services. It closed during the Great Depression.

125

Central School Building, Heilwood, Pa.

Heilwood has had three elementary schools. This central school building, located along Route 403, was erected in 1905. By 1912 Pine Township had opened a three-year high school here, the first township-supported high school in Indiana County. Behind this eight-room school building stood a dormitory, which housed the faculty of the high school.

The first person to settle in Greenville was John Evans, who came to the area in 1804. He married Elizabeth McFarland in 1804, and their son William was born in 1808. In 1838 William Evans decided to form a town he called Greenville, so named because it was in Green Township. His store was the first one in town, and it housed the post office that opened in 1839, called Penn Run. Andrew Wiggins was the first postmaster.

The first gristmill in Penn Run was run by J.M. Barr. It burned on January 1, 1885, and was rebuilt by J.C. Rugh, Frederick Cameron, and William McFeaters, with a roller press installed in 1886. Cameron sold out to McFeaters, and McFeaters sold out to William Fair, who sold his interest to James Fowler. John Lytle bought the mill on January 1, 1913, and operated it as the Penn Run Roller Mill.

The German Baptist Church in Penn Run was originally built in 1868 by the United Presbyterians. The German Baptists, or Dunkards, purchased it in 1905 from the United Presbyterians when their congregation ceased to exist. The first minister was Adam Helman, in 1845. In 1908 the annual conference renamed the church the Church of the Brethren of Penn Run. A parsonage was added, along with a picnic shelter for recreational activities.

The Presbyterian Church of Penn Run can trace its lineage back to the Harmony Presbyterian Church, which originated in 1806. Members built a log church *c.* 1820 and replaced it in 1844 by a frame church. This 58- by 38-foot church, completed in 1883 at a cost of over $4,000, was situated next to the Penn Run Methodist Church. The two churches merged formally on November 5, 1967. Because the Presbyterians outnumbered the Methodists, it was named the Harmony United Presbyterian Church.

The first school building in Greenville was the Cherryhill Township School No. 9. A fire destroyed this school in 1875, and a new school (pictured here) was erected in 1876. It was a two-story frame structure built on a lot near the Etta Houck property. This "knowledge box," as it was described on the postcard, was used not only as a public school but also by the Greenville Academy. Cherryhill Township High School opened in 1915, the last three-year high school in the county.